EXE TO OTTER

THROUGH TIME

Christopher Long
& Kay Long

AMBERLEY PUBLISHING

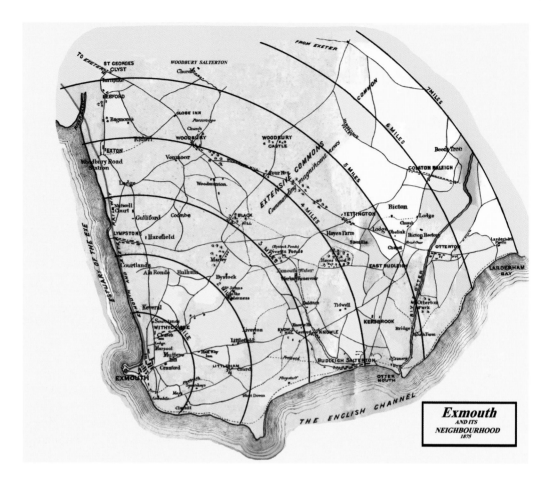

Map of Area (1875)

To help guide you around this beautiful area, we have included postcodes for the sites featured. Use these with your sat-nav or to search on the internet for directions.

First published 2012

Amberley Publishing
The Hill, Stroud
Gloucestershire, GL5 4EP

www.amberley-books.com

ISBN 978 1 4456 0719 1

British Library Cataloguing in Publication Data.
A catalogue record for this book is available from the British Library.

Typeset in 9.5pt on 12pt Celeste.
Typesetting by Amberley Publishing.
Printed in the UK.

Introduction

Exe to Otter Through Time is the second book in this series written by Christopher Long who, with his wife Kay as co-author, has used the same format as his successful book *Exmouth Through Time*, published in 2010 and reprinted in 2011. The inspiration for this book came from the map shown opposite taken from the *Freemans Visitor Guide of 1875* entitled 'Exmouth and Its Neighbourhood'.

Many changes to the area have been captured using comparison images from the authors' extensive collection of glass slides, postcards, guidebooks and photographs, some of which are over 140 years old. The recent photographs help to show how the larger towns of Exmouth and Budleigh Salterton have altered considerably, whereas the smaller villages still maintain their charm and remain largely unchanged.

Building on their knowledge of the area with the kind assistance of local people and the volunteers of Exmouth and Budleigh Salterton Museums, Christopher and Kay encourage the reader to reminisce about bygone times while celebrating the beauty of East Devon.

The famous explorer, writer, poet, soldier and courtier Sir Walter Raleigh was local to the area in his youth, and they have pictured many of the places he was associated with, as well as some of the places that bear the family name in the area.

Christopher has previously co-written three reference books with Maurice Southwell, Elizabeth Gardner and Sally Stocker: *Withycombe Raleigh of Yesteryear* parts one and two (published in 2005); and *Images of England: Exmouth Postcards* (published in 2006).

Withycombe (Marpool) Mill
Taken in the summer of 1962, this photograph shows the Withycombe (Marpool) Mill with the four oldest children of Miller Harry Long, from left to right: Susan, Christopher (author), David and Stephen Long, and valued worker family friend Frank Bastin. Christopher's family connection with the mill has fuelled his passion for the history of the local area.

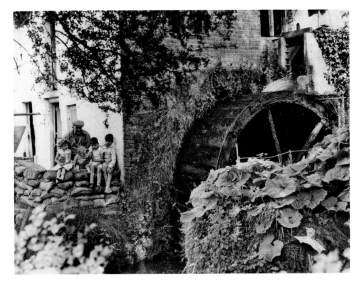

Acknowledgements

We would like to thank Jo Clarke, who has been an excellent sounding board, and David Stoneman, for helping with information on the local railways.

We would also like to thank James Long and Sally Stocker for their invaluable help with editing.

Our special thanks go to Julian Sleeman for allowing us access to Bill Sleeman's extensive collection of photographs and slides, which were invaluable in recording the changes to the area.

We are particularly grateful to the following who have either shared their photographs or stories helping to add depth and colour to the book:

Baileys (Exmouth) Ltd, *Exmouth Journal*, Exmouth Museum, The Fairlynch Museum, Margaret Brett, Helen Brown, Angela Coles, Emma Crane, Richard Crisp, Stuart Gardner, Tony Gibbson, Jean Grant, Brian Hart, Colin Heyde, Gos Holm, Colin Lock, Valerie Lister, Martyn Long, Nick Lowman, Jeanne Mallett, Derrick Mead, Sylvia Merkel, Sally and Chris Miller, Gerald Millington, Melanie Mock, Kathleen Moyle, Clive and Maureen Parnell, David and Alan Perkins, David Pratt, Maurice Southwell, Anne Scott, Roger Stokes, Richard Tarr, Michael A. S. Tuska and Daniel Wood.

Exmouth area coat of arms and Budleigh coat of arms.

CHAPTER 1

Exmouth Docks
& Seafront

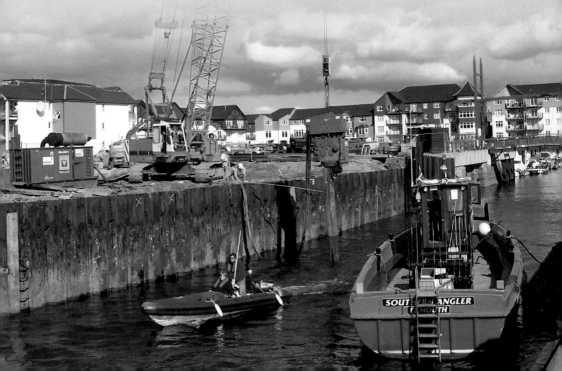

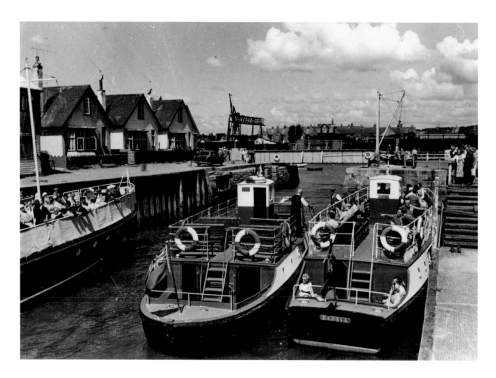

Exonia and *Orcombe*

The *Exonia* and *Orcombe* ferries to the right of this photograph *c.* 1960 were the Great Western Railway passenger link between Starcross and Exmouth. The *Devon Princess* pleasure cruiser is shown on the left with the Shelly Beach chalets visible on the dockside. The old swing bridge and the coal hoist can be seen in the background. Inset: Working on the old dock bridge in 1936. Below: The *Orcombe* ferry still operates today, enabling the Exe Estuary circular cycle route to be completed. (*Sat-nav: EX8 1XR – Clippers Wharf, The Marina*)

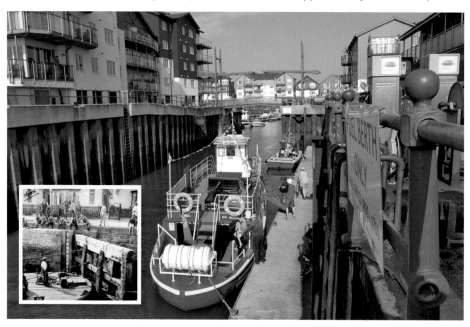

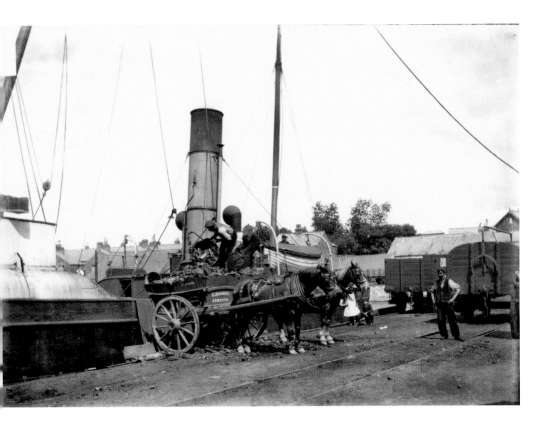

Exmouth Working Dock

Exmouth working dock was built in 1865. This photograph, *c.* 1900, shows coal being manually unloaded from an old steamer for transportation by horse and cart to the coal merchants. Note the railway track and rolling stock. Below: In sharp contrast, the marina in 2011 is mainly used for recreation. (*Sat-nav: EX8 1XA – The Marina*)

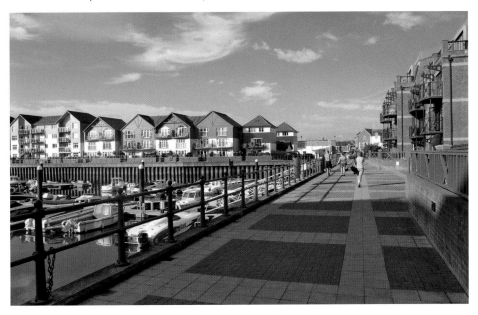

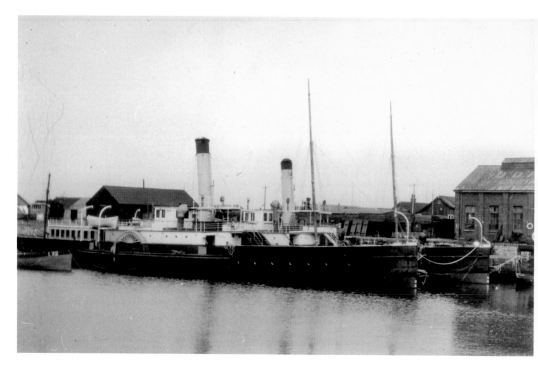

The *Duke* and *Duchess of Devonshire*
Sister paddle steamers, the *Duke* and *Duchess of Devonshire*, are seen here moored at the area known as Coal Quay, *c.* 1910. Built in London in the 1890s, they were the pride and joy of the Devon Dock Pier & Steamship Company and used for pleasure cruises along the South Devon coastline. Below: Looking along Coal Quay in 2011. *(Sat-nav: EX8 1XA – The Marina)*

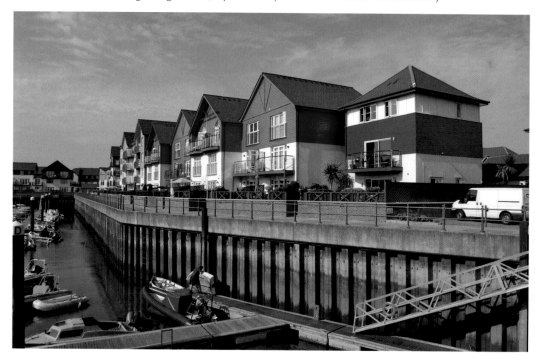

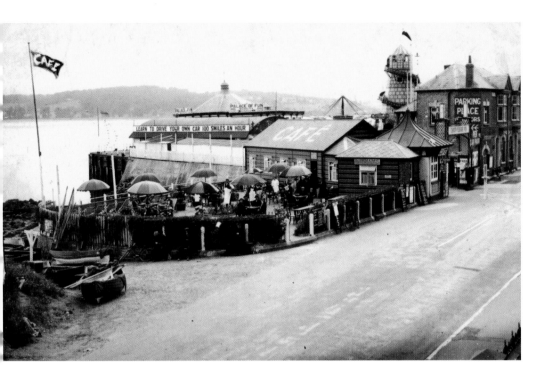

Mamhead Slipway and Exmouth Pier, *c.* 1920
The boats to the left of the photograph are resting on the slipway and the fairground can be seen on the pier behind the café. The roof of the pier's pavilion, which was demolished in the 1950s, can be seen in the background. Below: Barely recognisable, the same area in 2011. In the centre of the photograph is the slipway with modern metal floodgates. (*Sat-nav: EX8 1DS – Mamhead View*)

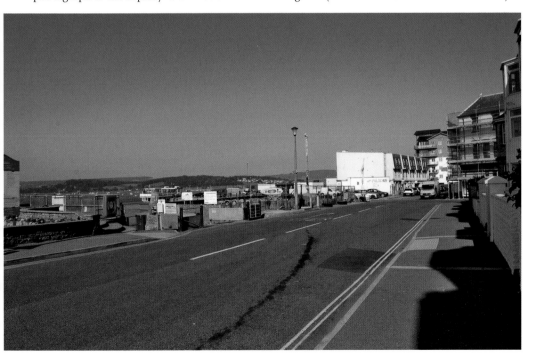

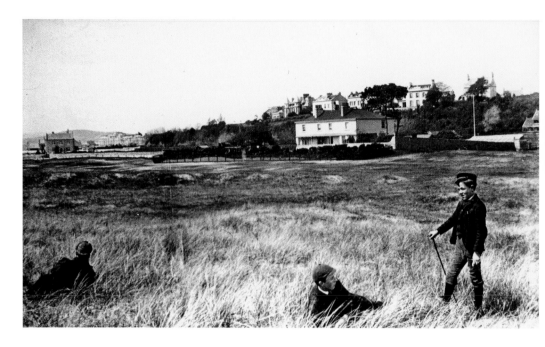

The Maer

The Maer *c.* 1900, when it was used as a nine-hole golf course (extended later to eighteen holes). Shell House in the centre of the picture was the home of Royal Academy artist Francis Danby from 1841 to 1861. Danby Terrace was named after this famous landscape painter, well known for his stunning sunset scenes. Inset: Lord Sanders' circus animals during a visit to the town *c.* 1900. Below: The Maer in 2011 still shows evidence of the golf links and continues to be popular for recreation. (*Sat-nav: EX8 2AY – Cricket Pavilion*)

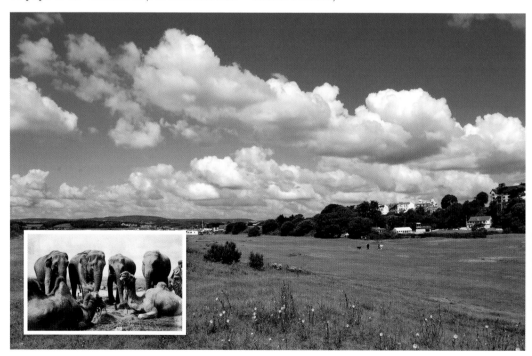

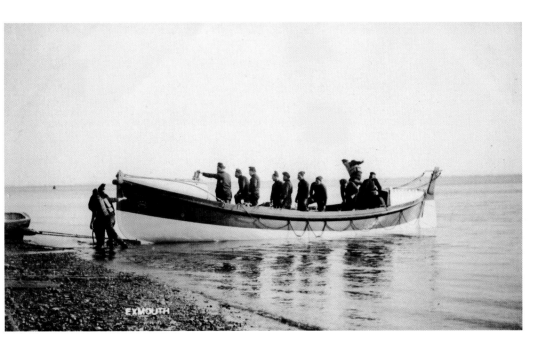

Exmouth Lifeboats

The Exmouth lifeboat, *Joseph Somes (II)*, operational from 1903 to 1933, was named in recognition of the donation from Mrs Somes following the death of her husband; the cost was £683. The thirteen-strong crew propelled this craft manually with oars and optional sails. Surprisingly, the lifeboat was only launched ten times during its operation in Exmouth, saving four lives. Below: *Margaret Jean*, Exmouth's lifeboat since 2008, on exercise in May 2010. In sharp contrast this lifeboat only has six crew members and is driven by two diesel engines. (*Sat-nav: EX8 2AY – Lifeboat Station*)

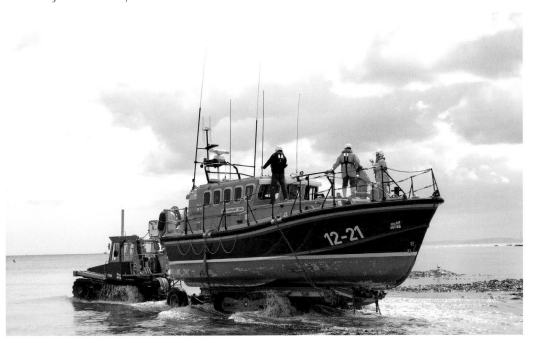

Exmouth Esplanade

Exmouth Esplanade *c.* 1880, before the clock tower was built in 1897 to commemorate Queen Victoria's Diamond Jubilee. The bathing machines behind the young man were used to transport bathers into the sea to protect their modesty. The wall to the right of the photograph is the boundary of The Imperial Hotel. Below: The same area was transformed when an estimated 20,000 spectators gathered to watch the Tour of Britain cycle event on 15 September 2011. (*Satnav: EX8 2SW – The Imperial Hotel*)

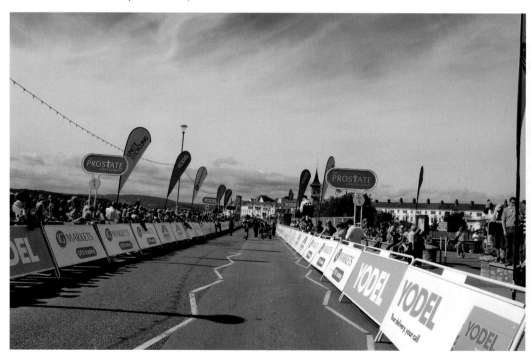

Exmouth Beach
The gas lamp, railings and bandstand of Beach Gardens can be seen to the right, *c.* 1905, showing the ornate architecture of the era. Note the high level of the sand against the sea wall and the Harbour View lookout tower in the background. The octagonal mobile bathing machine can be seen to the right. Below: Reminiscent of the 1900s bathing machine, The Octagon in 2012 sells ice creams, snacks and refreshments. The Art Deco pavilion, shown to the left of the photograph, opened in July 1933, providing a state-of-the-art entertainment facility for 740 people. (*Sat-nav: EX8 2AY – The Octagon*)

Marine Drive and Lifeboat Station
This image was captured during the construction of Marine Drive in 1911. The outbreak of the First World War in 1914 delayed the work and the road was not completed until 1920. The scaffolding to the right shows the position of the sea wall. Below: The lifeboat station, completed in December 2009, houses both the *Margaret Jean* lifeboat and the offshore lifeboat, *George Bearman*. (*Sat-nav: EX8 2AY – Lifeboat Station*)

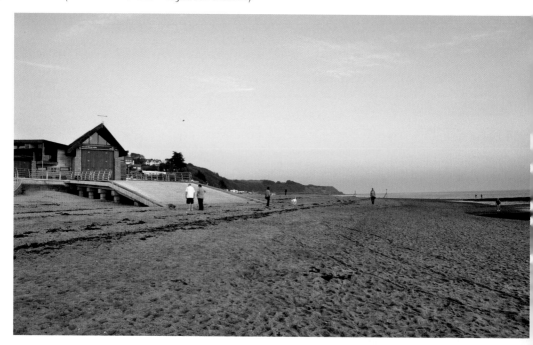

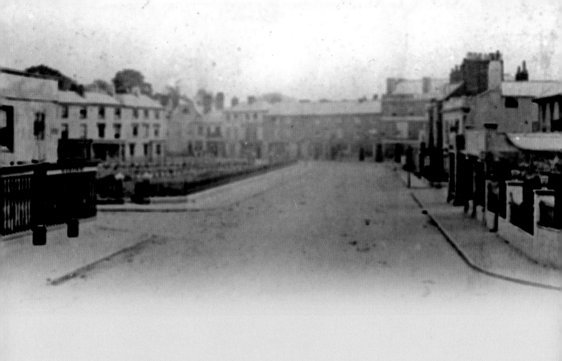

CHAPTER 2

Exmouth Town

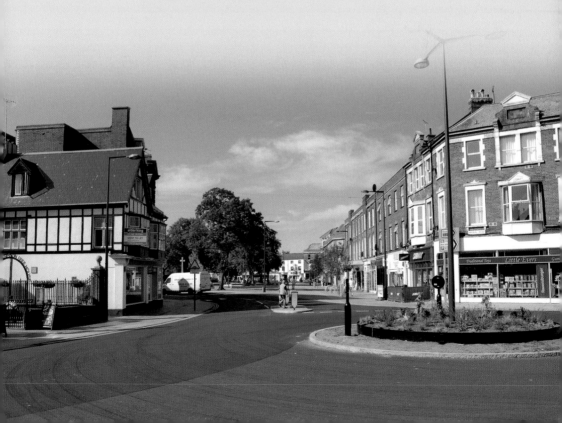

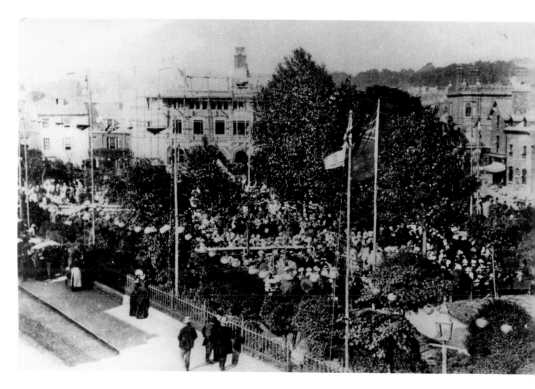

The Strand

A view of the Strand during Queen Victoria's Diamond Jubilee in 1897; a day of celebrations, with tea parties for local children, pensioners and adults. The large building in the background is the old town hall, now the Savoy cinema and shops. Below: The redeveloped Strand area on 4 June 2012, during Queen Elizabeth II's Diamond Jubilee celebrations. (*Sat-nav: EX8 1AG – The Strand*)

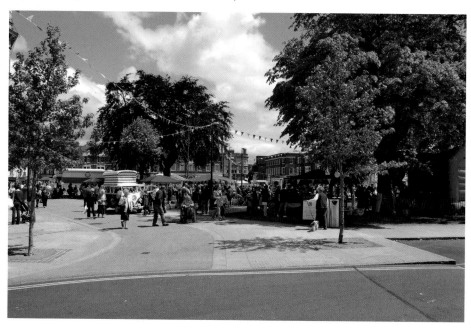

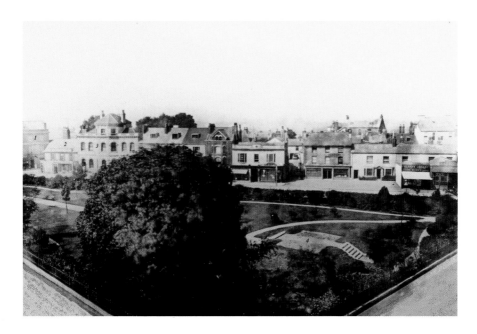

Redevelopment

Waters Railway Hotel (far left) and the post office (next to it) were demolished in 1897 to allow for the Victoria Road entrance onto the Strand. The old Wiltshire & Dorset Bank (third building from left) is one of the few buildings in this area of the Strand that survived the bombing on 26 February 1943. The enclosed gardens pictured, c. 1880, are still in their infancy with the steps leading to the raised open-air bandstand. Below: The war memorial is the only structure untouched by the redevelopment of the Strand gardens, which opened in December 2010. (*Sat-nav: EX8 1AB – Exmouth Market on The Strand*)

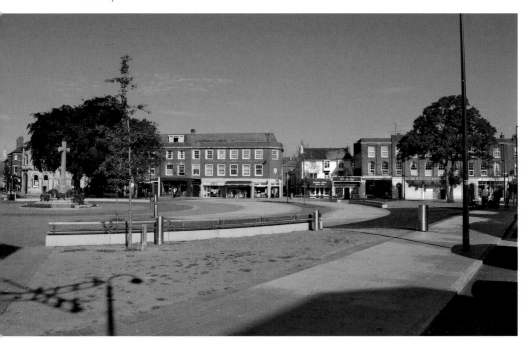

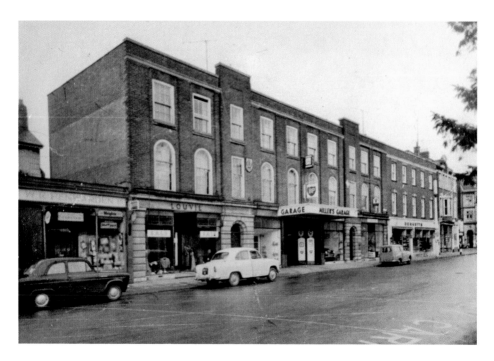

Millers Garage and Exmouth Market

Millers Garage, *c.* 1960, when they were an agent for Morris & Wolseley cars. Between the First and Second World Wars they offered omnibus and touring services for holidaymakers. Note the old petrol pumps in the days before self service. Since 26 July 1980 the building has been used as Exmouth's indoor market. Below: The transformation of the Strand from garden to piazza in 2010. Exmouth Market, seen in the background, today boasts 'fifty traditional market stalls offering something for everyone'. (*Sat-nav: EX8 1AB – Exmouth Market*)

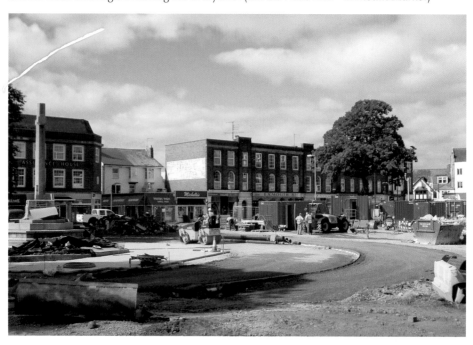

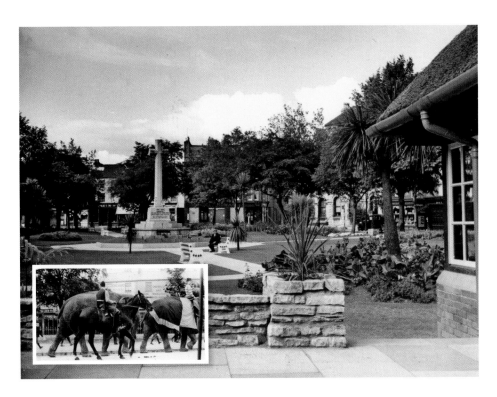

Savoy Cinema and War Memorial

The Strand, *c.* 1965, looking from the Savoy cinema with the old thatched shelter in the foreground. The war memorial was erected in 1920 to commemorate the lives lost in the First World War and later conflicts. Inset: The circus comes to town, *c.* 1880. Below: The wide-open space of the newly developed pedestrianised Strand offers a versatile area for public events. (*Sat-nav: EX8 1HL – Tourist Information Centre, The Strand*)

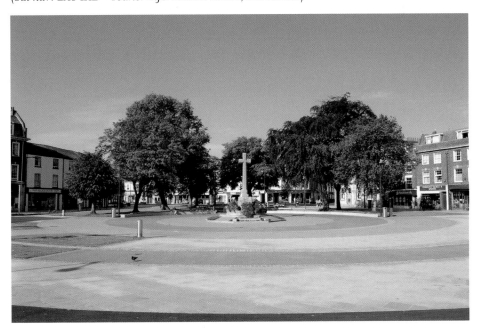

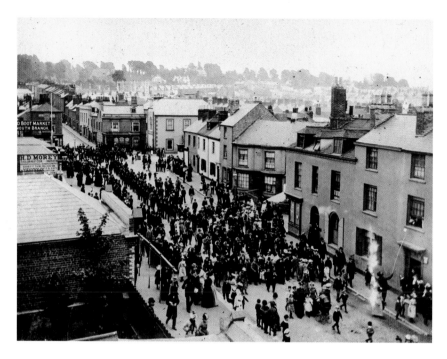

A Parade on the Parade in 1892

Taken from the upper window of what is now Bailey's Outfitters, this busy scene shows the Exmouth Friendly Society in their finery, accompanied by a brass band. The Friendly Society's campaign at that time was to support self-help against poverty. The man in the foreground can be seen collecting donations from people in the upper windows. Below: The area has seen considerable redevelopment, as shown in this photograph taken in 2011. (*Sat-nav: EX8 1RE – The Parade*)

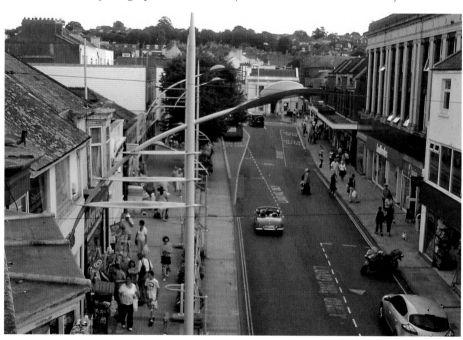

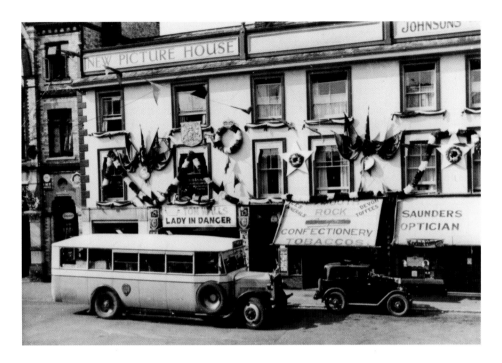

The Parade

The bunting and flags help to date this photograph to May 1935 during King George V's Silver Jubilee celebrations. The town celebrated with a programme of exciting events, including a Ladies Ankle competition with a prize of 5 shillings! The New Picture House, later known as The Forum, was showing *Lady in Danger*. Outside, the Exeter-bound coach can be seen and in front of this is a Standard car. Below: The same area of the Parade taken in 2011. The New Picture House entrance was where the Fahrenheit sign is displayed. (*Satnav: EX8 1RS – The Parade*)

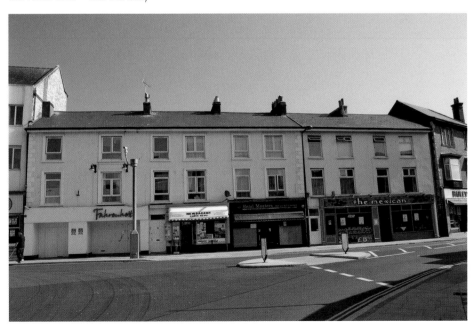

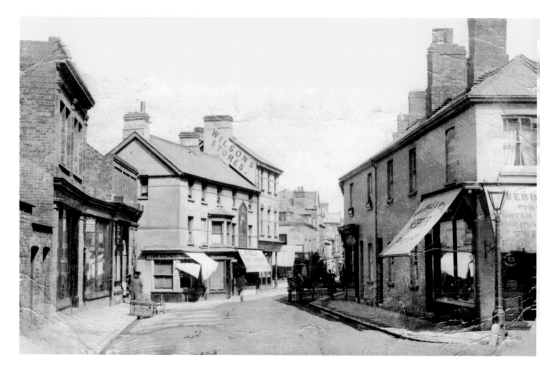

Chapel Street

This rare postcard of Chapel Street, *c.* 1900, gives an insight into life at that time. Sadly, the area was severely damaged during a German air raid in 1941. Below: Better known today as the Magnolia Centre, the area has been totally rebuilt and is no longer open to traffic. The centre was opened by television personality Angela Rippon in 1979. The post office building, to the right of the photograph, was built in July 1973. (*Sat-nav: EX8 1LU – The Post Office*)

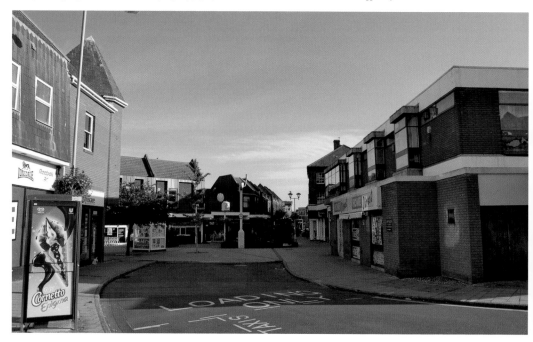

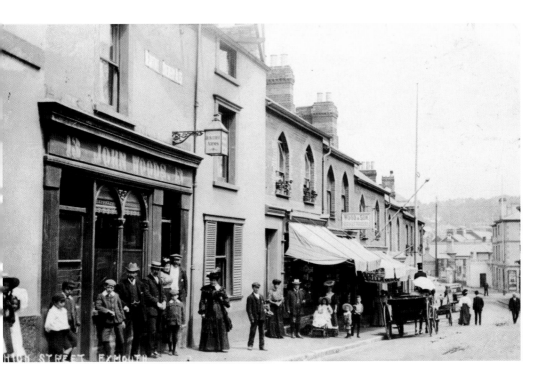

High Street

This photograph of High Street was taken *c.* 1902. The lamp above 13 John Woods frontage shows that even at this early stage, the Heavitree Arms was operating as a licensed public house. Notice how everyone is posing for this photographic opportunity. High Street was formerly the upper end of Chapel Street before it was split by the creation of Rolle Street in 1875. Below: The Heavitree in 2011 still displays the same ornate arched windows and remains a popular drinking venue. *(Sat-nav: EX8 1NP – The High Street)*

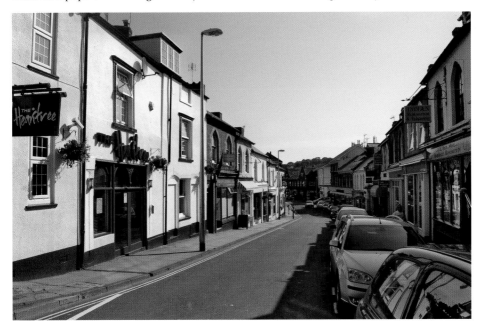

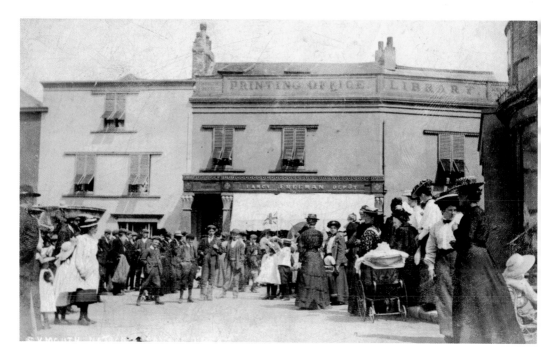

Exmouth Journal Office

This postcard *c.* 1903 titled 'Exmouth National School Treat' shows a celebratory event. To the right of the photograph is the curved brickwork of the Temple Winds building, a pharmacy for over 130 years, and helps to place the image at the bottom of Beacon Place. The printing office and library housed Freeman's *Exmouth Journal* office, which was founded in 1882. Below: A new building on the site, built in 1912 and extended in 1927, continued to house the *Journal* office and is now used by Bentley's garage. Although the garage no longer supplies fuel, until this service ended in May 2010 it was the last in Exmouth to have a petrol pump attendant. (*Sat-nav: EX8 1NN – Bentley's Garage*)

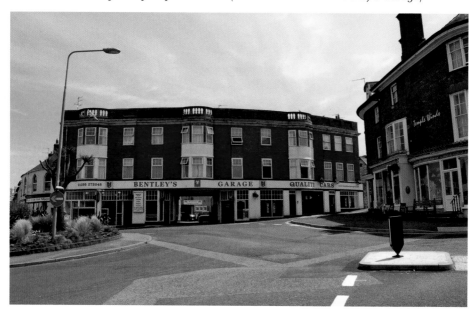

Cinemas

The Royal Cinema, formerly known as The Grand, was taken over by Scott Cinemas in 1963 but closed in 1979. At the height of cinema popularity, this picture house was just one of four in Exmouth. The other three were: The Forum on the Parade, The Regal in St Andrew's Road and The Savoy, which remains in operation today, in Rolle Street. Below: The same area in 2011 has been developed to become Glenorchy Court. (*Sat-nav: EX8 1PJ – Glenorchy Court*)

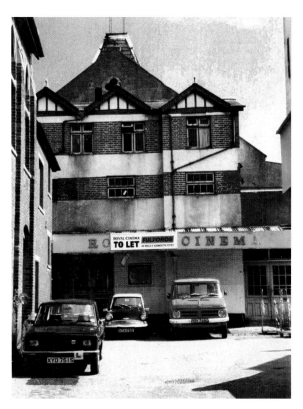

Exeter Road

The top of Exeter Road looking towards Phear Park, *c.* 1985. The viaduct was a feature for nearly twenty years following the closure of the railway line to Budleigh Salterton in 1967. The railings in the centre of the picture mark the Withycombe Brook flood relief culvert which was built in the early 1960s. Below: Taken in summer 2011, the area is now enhanced by the Britain in Bloom flower displays. Modern flats have been built on the site of the old viaduct. (*Sat-nav: EX8 1QG – Exeter Road*)

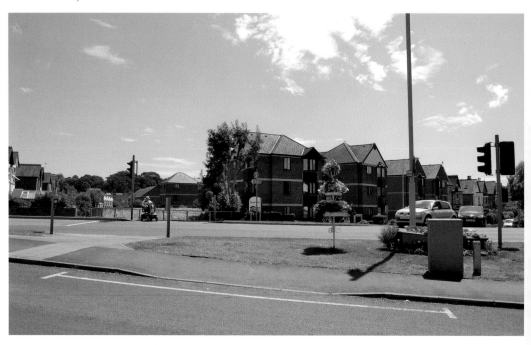

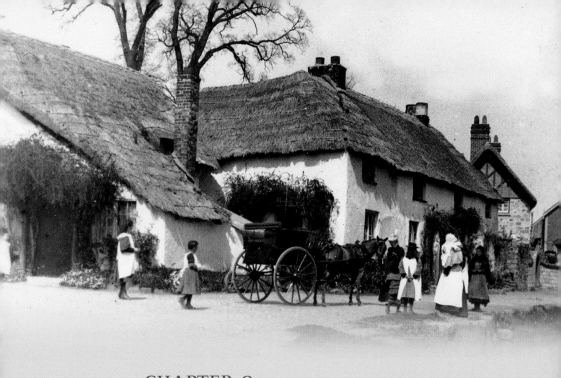

CHAPTER 3

Outskirts of Exmouth

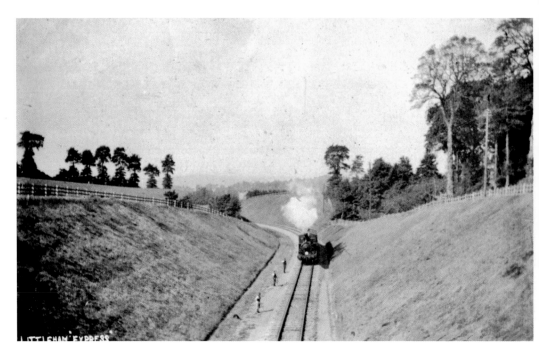

Littleham Express

Believed to be on its maiden trip, *c.* 1903, the *Littleham Express* is travelling along the route from Exmouth to Budleigh Salterton. This line operated from 1903 to 1967 when it was discontinued as part of Dr Beeching's cuts to the rail service. Below: The old railway line is now used as a pedestrian and cycle path. The houses in Lovelace Crescent can be seen to the right of the photograph. (*Sat-nav: EX8 4AH – Bradham Lane*)

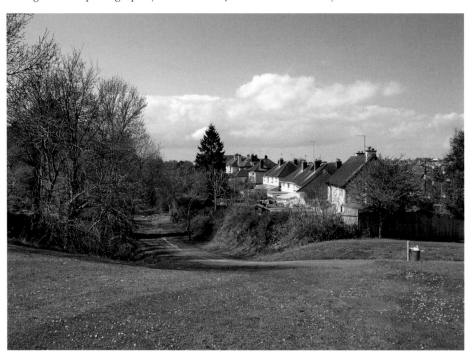

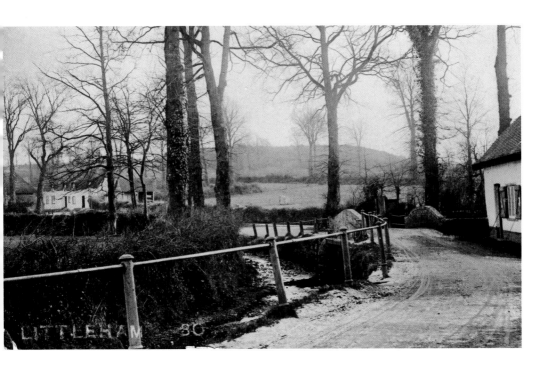

Mundy's Farm Cottages

This photographic postcard, *c.* 1904, is a rare image looking towards Mundy's Farm Cottages, with Littleham Forge on the right. A winter scene allows a clear view of the unspoilt rural approach to Westdown Farm, Sandy Bay. The narrow humpback bridge crosses the Littleham Brook as it flows down towards the Maer and out to sea. Below: In 2011 the same area has become an urbanised extension of Exmouth. (*Sat-nav: EX8 2RL – The Clinton Arms, Littleham Village*)

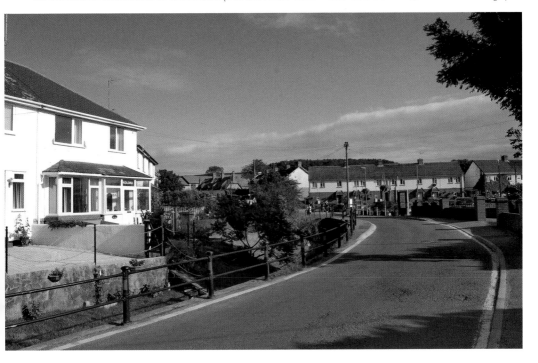

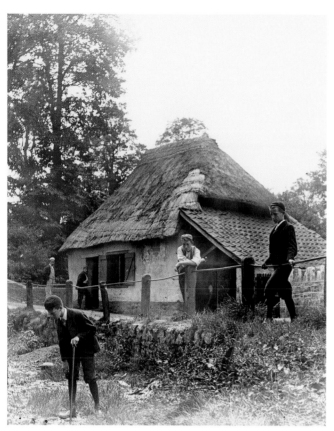

Littleham Forge

Taken from a glass slide entitled 'Looking for the Lost Ball', this picture shows Littleham Forge, *c.* 1900, giving an insight to life at that time. The Forge building remained a feature of Littleham Village until it was demolished in 1975. Below: The old forge is remembered in the name of the house which stands on the same site, shown in the centre of the photograph. The Clinton Arms is visible in the background. (*Sat-nav: EX8 2RL – The Clinton Arms*)

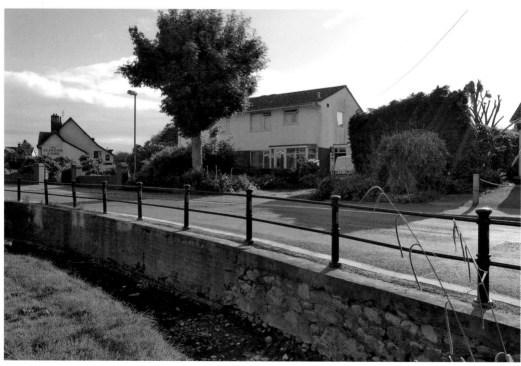

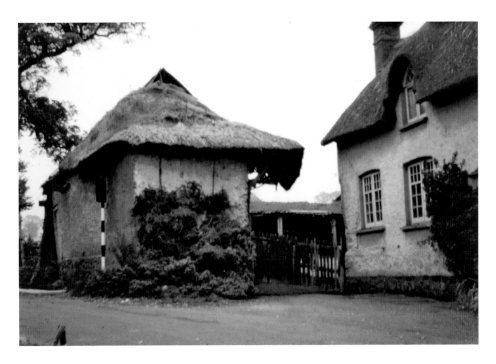

Shapter Court

Mundy's Farm Cottages, with the cob and thatched barn, *c.* 1964, shows the peaceful charm of Littleham at that time. In the 1860s, the cottages were used as a public house known as 'The Country House Inn' until it was divided to form two separate dwellings. Below: The farmyard was sympathetically developed in 2010/11 to provide the eco-friendly housing of Shapter Court, where the majority of the homes have outside power points for charging electric cars. (*Sat-nav: EX8 2RQ – Littleham Village*)

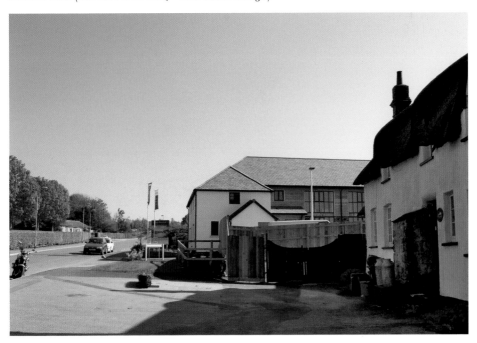

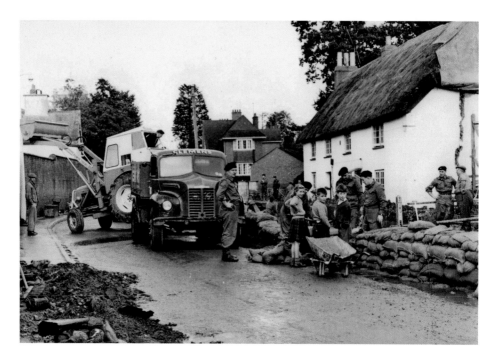

Mill Cottages

This photograph shows Mill Cottages, Withycombe Village Road, following the flooding in October 1960; the second event in as many months. Due to the severity of the damage the cottages were subsequently condemned and demolished. In 1962, as part of the Flood Relief Scheme, the Withycombe Brook was repositioned, widened and deepened to protect both Withycombe village and lower parts of the town from further flooding. Below: The same area in 2011. The white house to the left of both photographs helps to demonstrate how the area has changed. (*Sat-nav: EX8 3AE – Withycombe Village*)

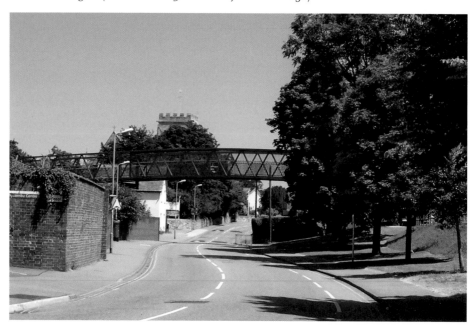

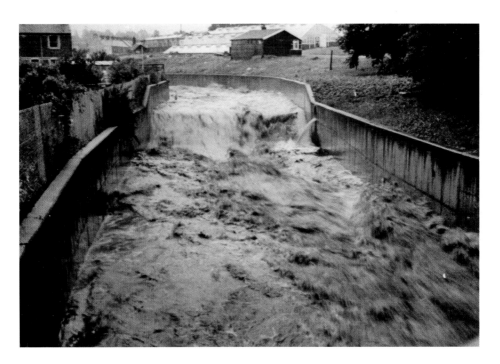

Withycombe Floor Relief

Withycombe Flood Relief channel in full flow, *c.* 1968. The Council nursery in Moorfield Road, to the right of the picture, produced plants for floral displays in the parks, gardens and public spaces of East Devon, before its closure in 1985. Below: Following extensive summer rain, this photograph was taken from Moorfield Road on 7 July 2012. Behind the trees to the right of the photograph is Nursery Close. (*Sat-nav: EX8 3RE – Nursery Close*)

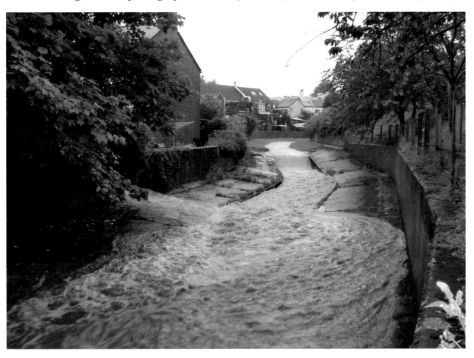

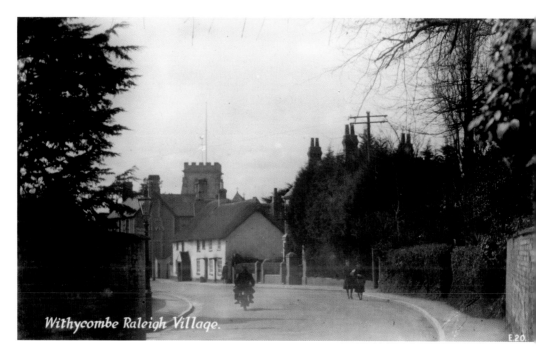

Withycombe Raleigh Village.

Withycombe Raleigh, c. 1930

Withycombe formed part of East Budleigh parish until 1850, when it became a parish in its own right. Porch Cottages, the thatched, white cottages in the centre of the photograph are some of the oldest in Exmouth, built *c.* 1600. They are said to be haunted. Below: This image captured on 20 December 2010 shows the village covered in snow that remained to give the rare event of a white Christmas. (*Sat-nav: EX8 3AG – Porch Cottages*)

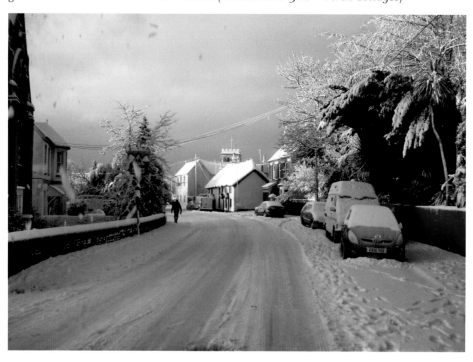

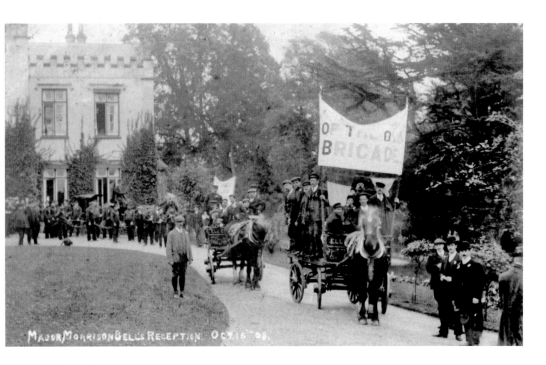

Caption in image: MAJOR MORRISON-BELL'S RECEPTION. OCT 16 '08.

Withycombe House

This photograph dated 16 October 1908 was taken in the grounds of Withycombe House during the reception of Major Clive Morrison-Bell, a veteran of the Boer War, who was elected in 1910 as a Member of Parliament for the Conservative Party, serving the Honiton ward for twenty-one years. Below: Withycombe House became a boarding school for children with behavioural difficulties and changed its name to Hillcrest School until its closure in July 2004. This picture, taken in 2011, shows Hillcrest School awaiting redevelopment for residential purposes. (*Sat-nav: EX8 4ED – Hill Crest Bungalow*)

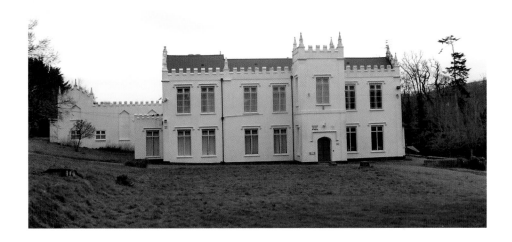

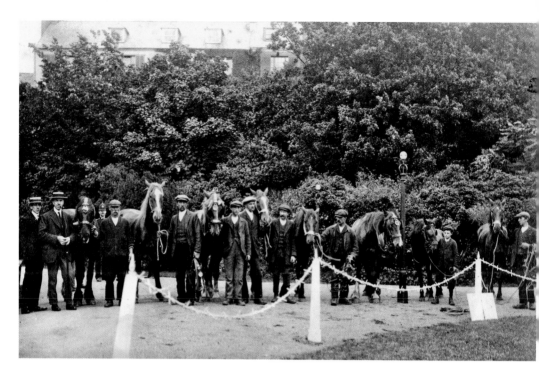

Buying Horses at Exmouth

Taken by local photographer Robert George Murduck, *c.* 1914, this picture is entitled 'The Government Buying Horses at Exmouth'. These unfortunate animals were being selected to join the war effort, as depicted in the novel *War Horse* by Michael Morpurgo. The houses on The Beacon can be seen in the background. Below: A gallop along the beach 2010, the epitome of leisure. (*Sat-nav: EX8 2AZ – Pavilion Gardens, Exmouth Seafront*)

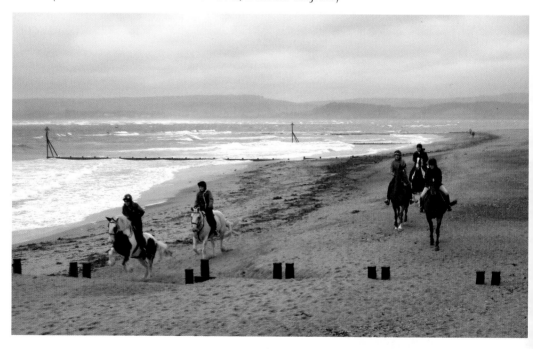

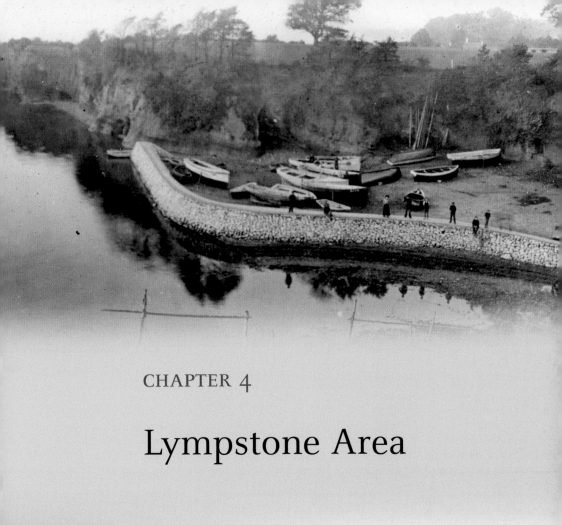

CHAPTER 4

Lympstone Area

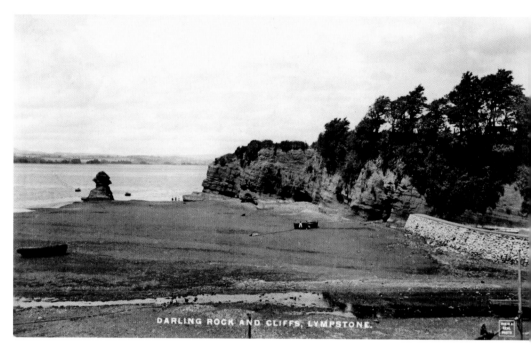

Darling's Rock and Cliffs, *c.* 1908
Legend has it that Darling's Rock (*left*), was so named because fishermen's wives sang loudly from its top to safely guide their men folk home through dense fog. The boat shelter to the right with the curved wall was destroyed by storms in 1912 but was reconstructed by fishermen and volunteers in 1936. Below: Darling's Rock in 2011 has been significantly eroded. (*Sat-nav: EX8 5EX – Lympstone Sailing Club*)

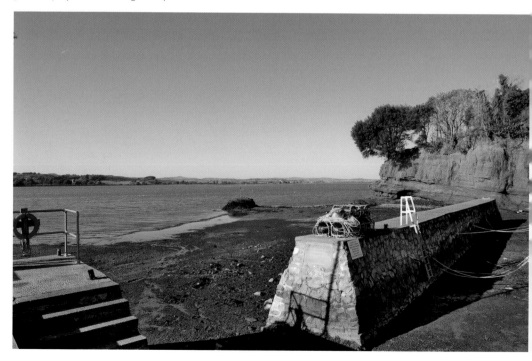

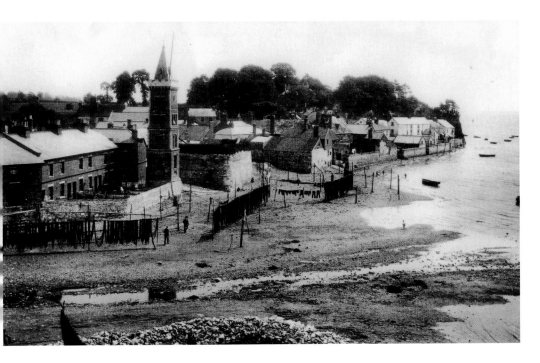

Peter's Tower

Inspired by St Mark's church tower in Venice, Peter's Tower (left of centre) was built in 1885, funded by wealthy merchant William Peters as a memorial to his late wife. Note the fishermen's nets hung for drying and mending on the foreshore. Below: Today, Peter's Tower is owned by the Landmark Trust and can be hired as holiday accommodation. The building to the right of the tower is a disused limekiln. Laundry now replaces the fishermen's nets. (*Sat-nav: EX8 5HQ – St Peters Tower*)

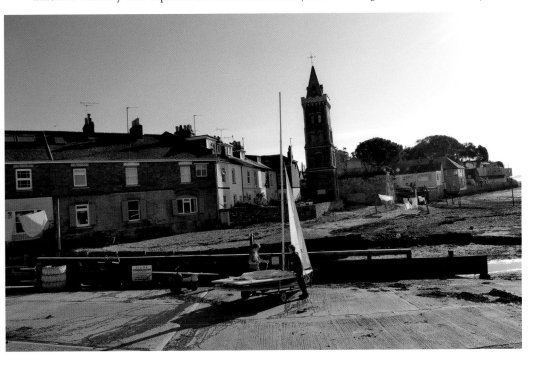

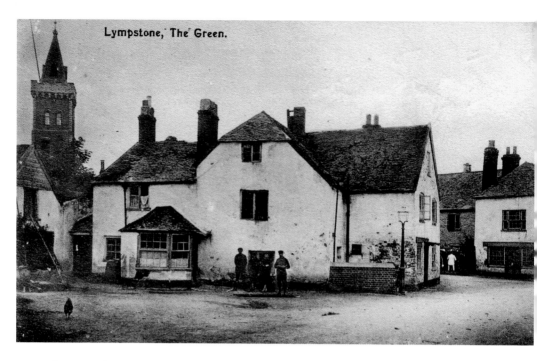

Lympstone, The Green.

The Green in Lympstone, c. 1904

The building to the right is currently used as a post office, a long standing feature of the village. From 1808, the post office used a horseshoe-shaped hand stamp bearing the name of Lympstone, until the Exeter Penny Post was established, *c.* 1814, when it was replaced with a hand stamp displaying the number 12. Below: The same area in 2011 shows how the village has been updated with the addition of a slipway and modern utilities. The white building in the centre of the photograph was rebuilt in 2011. (*Sat-nav: EX8 5EY – Lympstone Post Office*)

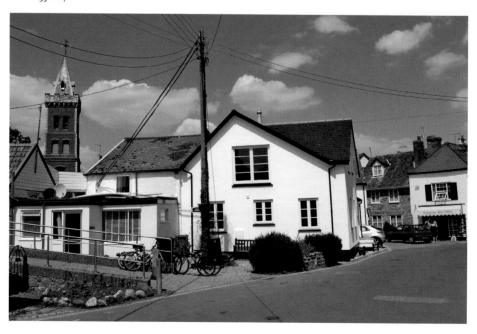

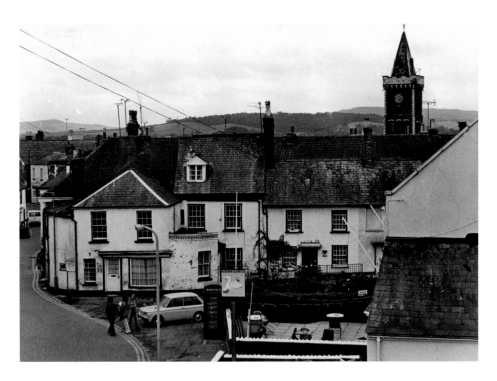

The Swan Inn, *c.* 1975

When the Exeter–Exmouth railway line opened in 1861, the inn was renamed The Railway Inn, but subsequently reverted to its original name in 1961. Lympstone had two banks in the early 1900s – National Provincial Bank and Lloyds Bank – both of which only opened on Thursday mornings for payday. Below: In 2011 the Swan Inn is a popular stopping point for thirsty cyclists using the Exmouth to Exeter Route of the National Cycle Network. (*Sat-nav: EX8 5ET – The Swan Inn*)

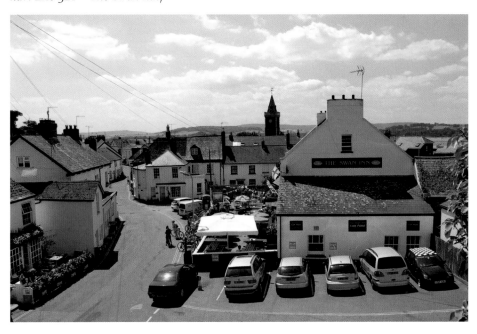

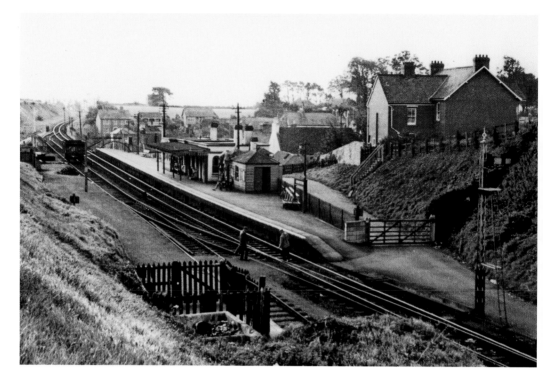

Lympstone Railway Station, *c.* 1950
At that time, local outgoing cargo included mussels and oysters and there was a loop off the main line for loading livestock. This closed on 16 September 1962. The station was renamed Lympstone Village in 1991 when the additional stop for Lympstone Marine Camp opened. Below: This photograph was taken in 2011 when this railway, now known as the Avocet Line, celebrated 150 years of service. The national cycle route can be seen to the right of the picture. (*Sat-nav: EX8 5ET – The Swan Inn*)

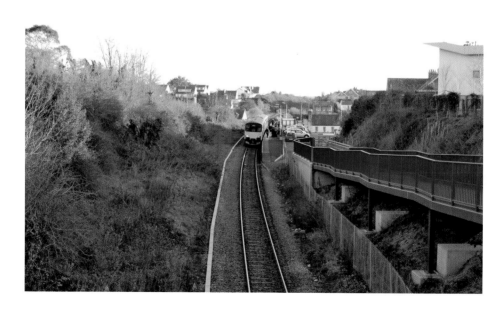

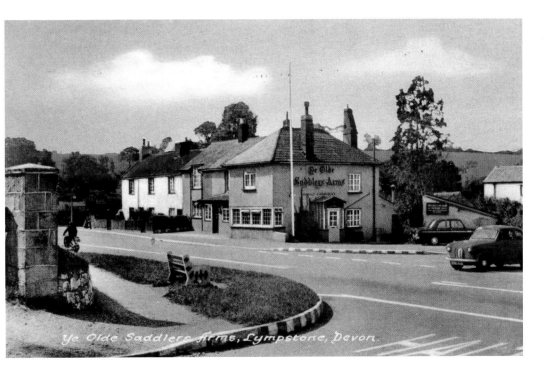

Ye Old Saddlers Arms

Ye Olde Saddlers Arms public house, *c.* 1960, was formerly a saddlery, harness maker and farriery. In the 1920s the adjoining land was used as a cattle market. Below: Today the two cottages adjoining the public house, now known as the Saddlers Arms, have been extended and merged. Located on the main Exeter to Exmouth road, it is ideal for passing trade and a welcome stopping point for the band and dancers of Lympstone's annual summer Furry Dance. There are three other pubs in the village: The Globe, The Swan Inn and The Redwing. (*Sat-nav: EX8 5LS – The Saddlers Arms*)

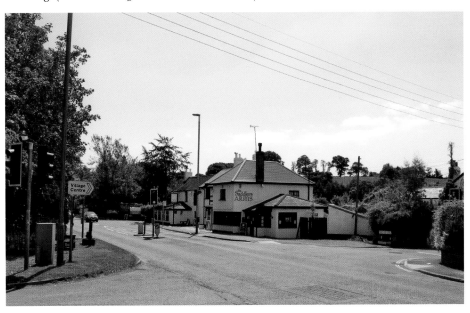

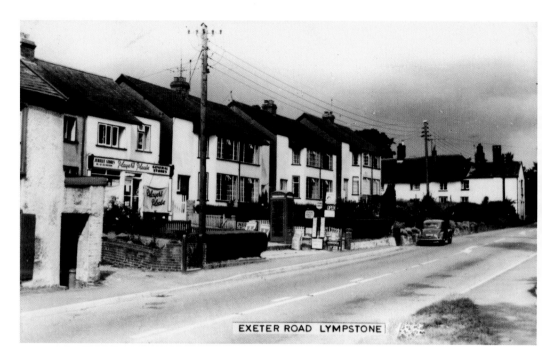

EXETER ROAD LYMPSTONE

Jubilee Stores

Pictured here *c.* 1965, the Jubilee Stores were purpose-built in 1935, the year of King George V and Queen Mary's Silver Jubilee. Situated along the main Exeter to Exmouth road, it was a general-purpose store selling everything from cigarettes to paraffin. Increased traffic, difficulties in parking and competition from larger stores prompted the owner, George Stuart, to sell and the shop closed at the end of the 1970s. Below: In 2011 all signs of the store, including the telephone box, have been removed. (*Sat-nav: EX8 5LU – Jubilee Grove*)

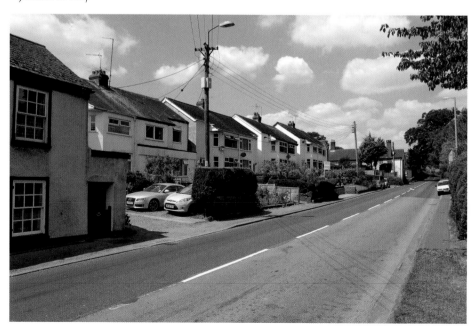

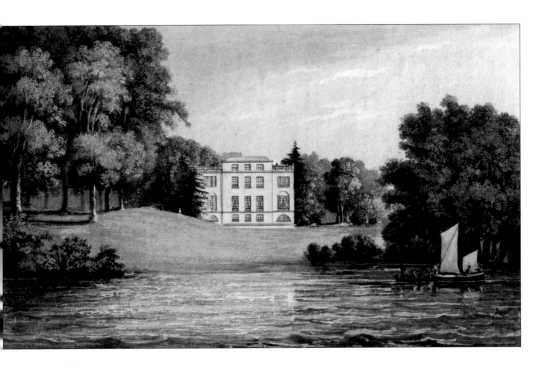

Nutwell Court

This handpainted print entitled *Nutwell Court From The River*, dated 1821, was once owned by ancestors of Sir Francis Drake. Although the house was rebuilt in the 1750s, with further design alterations in 1802, the fourteenth-century chapel remained unchanged (but it is no longer used as a chapel). Below: Nutwell Court in 2011 during a charity public open day held by the current owners, showing the beauty and grandeur of the gardens and ornamental lakes of this private house. Nutwell Court is no longer owned by the Drake family. (*Sat-nav: EX8 5AN – Nutwell Drive*)

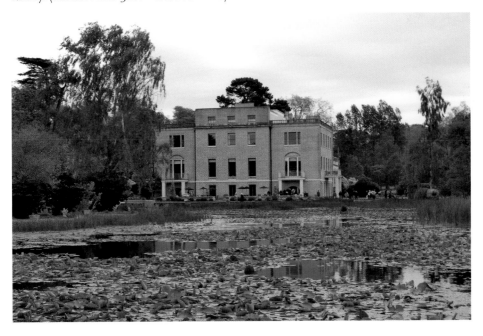

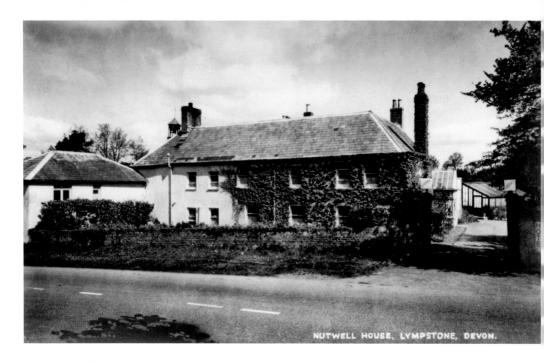

NUTWELL HOUSE, LYMPSTONE, DEVON.

Nutwell House

Titled 'Nutwell House, Lympstone, Devon' this postcard is evidence of the misconception that the Nutwell Court Estate is in the Parish of Lympstone, when it is in fact in Woodbury Parish. This building was the hunting lodge to the Nutwell Court Estate and used by guests of the Manor House until *c.* 1950 when it became the Nutwell House Hotel. Changes to the use of the estate extended beyond the lodge and included the building of the Lympstone Royal Marine Commando Training camp in 1938. Below: Today the Nutwell Lodge is a restaurant and free house. (*Sat-nav: EX8 5AJ – Nutwell Lodge*)

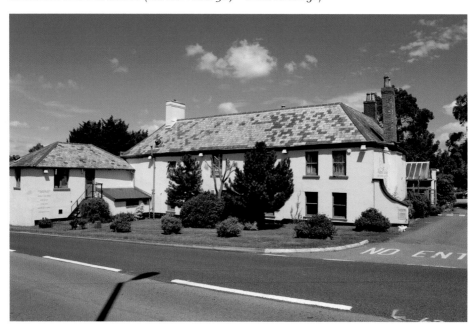

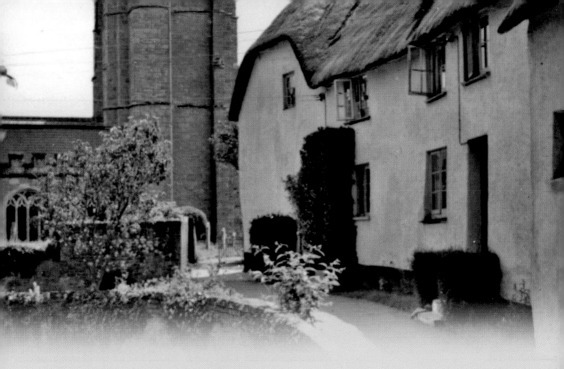

CHAPTER 5

Woodbury Area

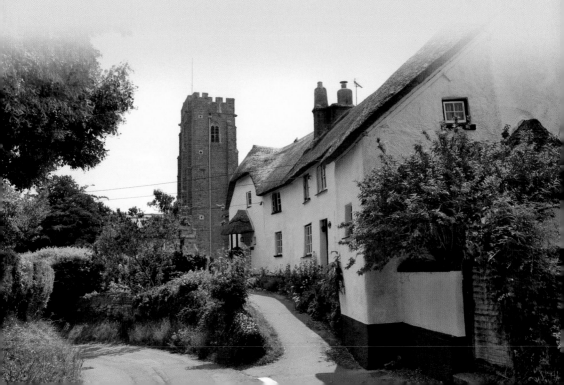

Bystock Reservoir
Taken in 1913, this photograph shows the boundary of Bystock Reservoir at the time when it provided water for Bystock House. Below: Pictured in April 2012, this beautiful area, now known as Bystock Ponds, has become a nature reserve managed by the Devon Wildlife Trust. The ponds form part of East Devon's Pebblebed Heaths Site of Special Scientific Interest. (*Sat-nav: EX8 5EA – Squabmoor Common*)

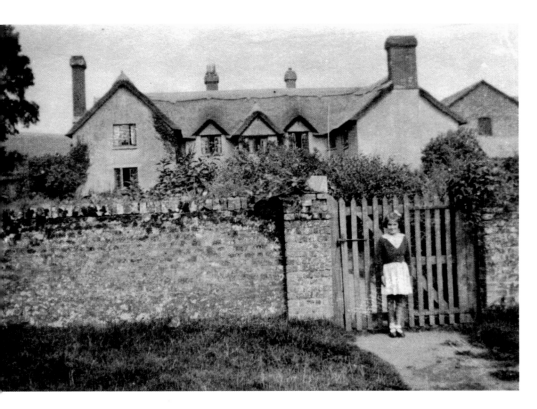

Hayes Barton

This picturesque cob-walled farmhouse is famous as the birthplace of Sir Walter Raleigh, and is where he spent his early childhood. The gabled ends and porch of the building form the letter 'E' signifying loyalty to Queen Elizabeth I. Below: Once open to the public, it is now a private dwelling. (*Sat-nav: EX9 7BS – Hayes Barton*)

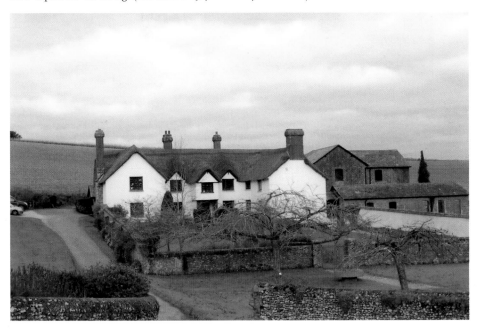

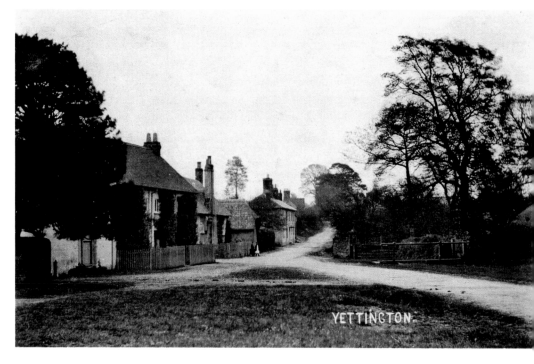

Yettington

This peaceful hamlet, historically consisting of cob-walled farmhouses, is situated on the edge of Woodbury Common approximately 3 miles from Budleigh Salterton. Below: Yettington, 2011. Today self-catering cottages give holidaymakers the ideal opportunity to stay in the heart of the East Devon countryside. (*Sat-nav: EX9 7BW – Yettington*)

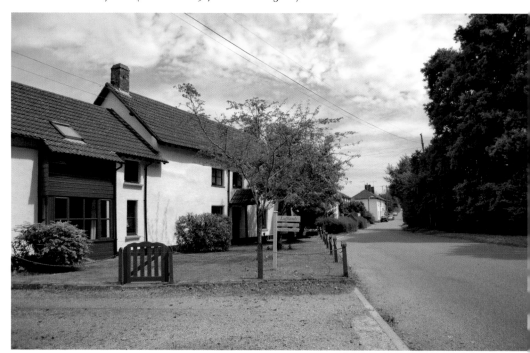

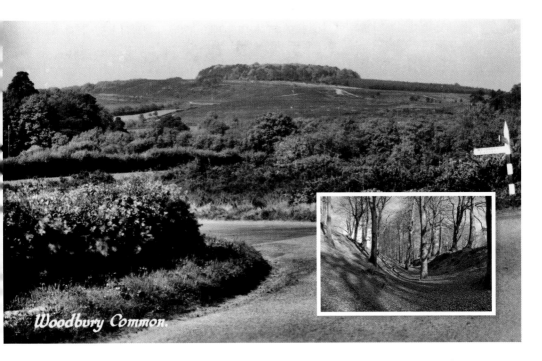

Woodbury Common.

Woodbury Castle

The wooded area at the top of this photograph, *c.* 1950, is the ancient earthwork fort of Woodbury Castle. There is evidence to suggest that it was occupied in the Iron Age between 500 and 300 BC. The site is the highest point of Woodbury Common, giving commanding views of the Exe Estuary and Lyme Bay. Inset: The ditch and ramparts of Woodbury Castle. Below: April 2012, looking across Woodbury Common towards Woodbury Castle, which is within the group of trees in the centre of the photograph. (*Sat-nav: EX5 1JJ – Woodbury Common*)

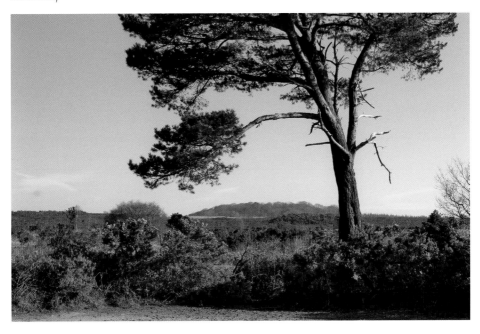

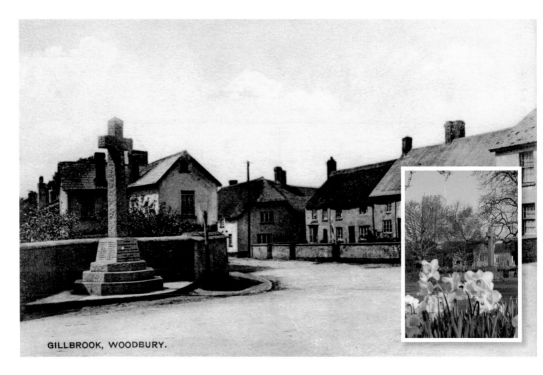

GILLBROOK, WOODBURY.

Woodbury War Memorial

Erected by volunteers in memory of local servicemen who lost their lives in the First World War, the Woodbury war memorial was unveiled by Major Clive Morrison-Bell MP, on 10 June 1920. Although originally located on the busy crossroads of Gillbrook and Broadway, it was relocated in the 1970s. Inset: it is now in the more peaceful setting on the Green, with St Swithun's church behind. Below: Broadway Junction in March 2012. The war memorial would have stood to the left of the post box. (*Sat-nav: EX5 1LQ – Woodbury Village*)

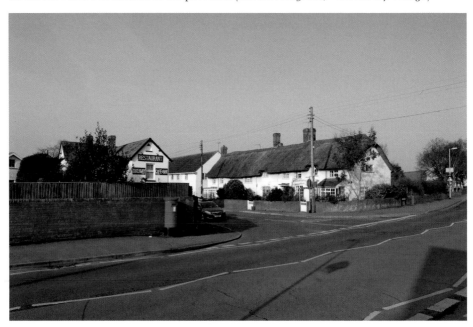

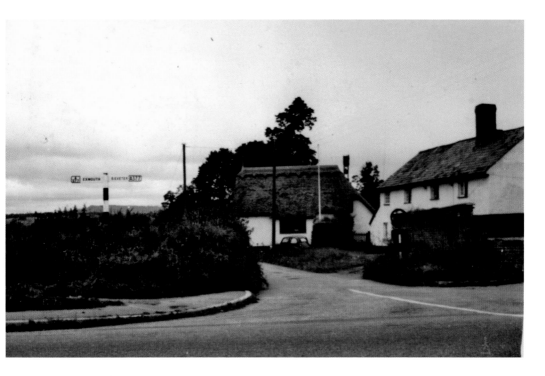

St Andrew's Church

St Andrew's church, Exton, *c.* 1930, was severely damaged and collapsed beyond repair during the floods of September 1960. Previously a cob-walled, thatched barn owned by the Rolle Estate, it was converted to a church in 1864, and donated to the parish the following year by Lady Rolle. The parish church for Exton at that time was St Swithun's at Woodbury. Below: St Andrew's church, 2011, is now located closer to the main Exeter Road. Its cross and belltower can be seen behind the trees to the right of the photograph. (*Sat-nav: EX3 0PQ – Exton Church*)

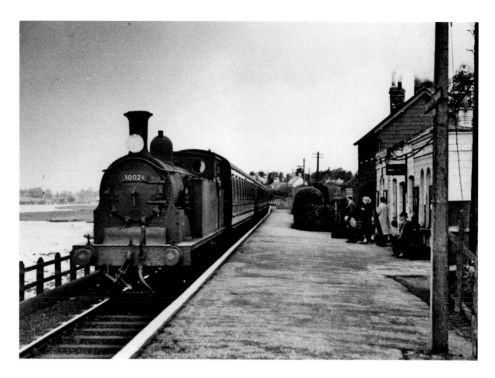

Woodbury Road Station

A Drummond Class 'M7' 0-4-4T 30024 steam locomotive on its arrival at Woodbury Road Station, which later became Exton Station in 1958. The early livery of the LSWR carriages helps date this picture to the late 1940s, pre-British Rail. This vital transport link between Exeter and Exmouth, opened 1 May 1861, saw 10,000 passengers in its first five days of operation. Below: A diesel class type 142 engine at Exton Station on its way to Exeter in 2011. The Avocet Line offers travellers stunning views of the Exe Estuary with its extensive variety of bird life. (*Sat-nav: EX3 0PR – Exton Railway Station*)

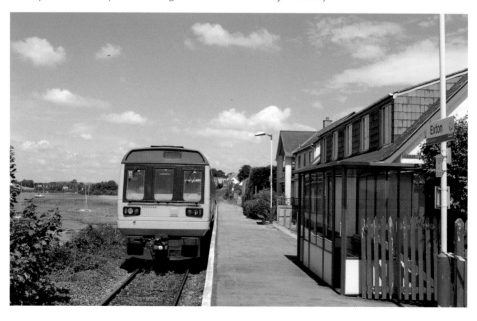

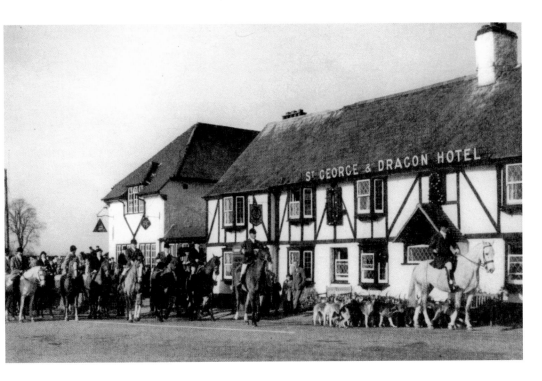

St George and Dragon

The East Devon Hunt outside the St George & Dragon, Clyst St George, *c.* 1960; an inn since the nineteenth century, originally comprising of a brew-house, gardens, stables and outbuildings set in 3 acres of arable land. During the Second World War, the bar was popular with RAF pilots, whose signatures remained a feature on the ceiling for some time after the war. Below: Retaining its rustic character and charm, the St George & Dragon in 2011 offers twenty-one bedrooms, a restaurant and bar. (*Sat-nav: EX3 0QJ – St George & Dragon*)

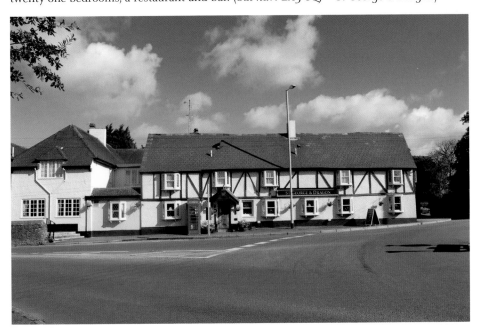

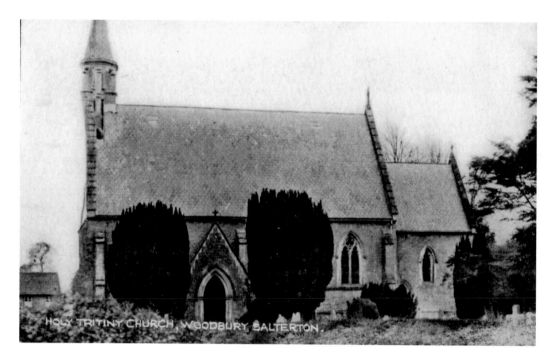

Holy Trinity Church

This rare postcard shows Holy Trinity church, Woodbury Salterton, *c.* 1910. Both the building of the church and school at Woodbury Salterton were funded by Marianne Pidsley; the church construction started in 1844. Below: Holy Trinity church in September 2011. The small belfry and spire was hit by lightning and repaired in 1923. However, in 1970 it was deemed unsafe and the three bells and spire were taken down. (*Sat-nav: EX5 1PR – Holy Trinity church*)

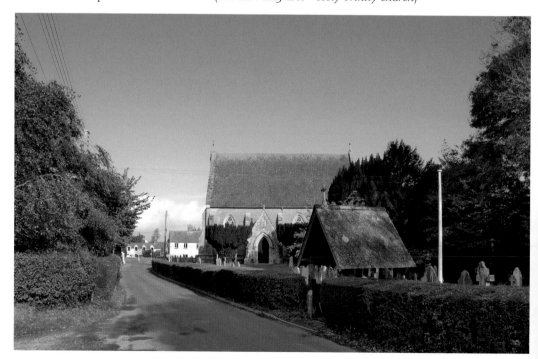

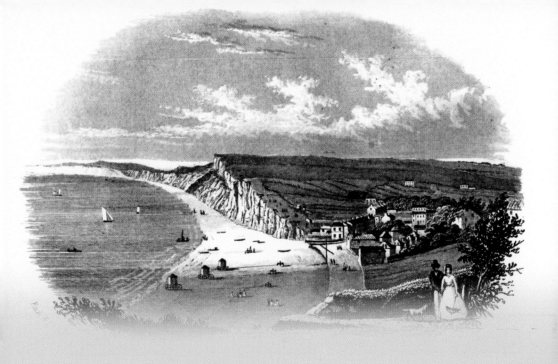

CHAPTER 6

Budleigh Salterton Seafront

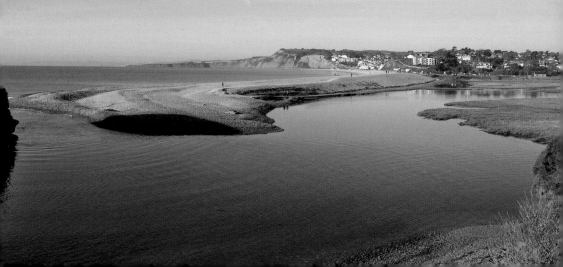

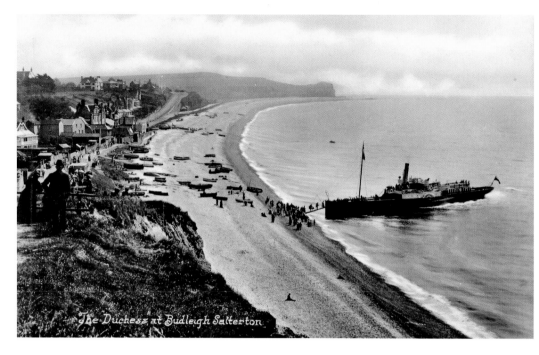

The Duchess at Budleigh Salterton

Duchess of Devonshire

Passengers embarking the *Duchess of Devonshire* paddle steamer at Budleigh Salterton seafront, *c.* 1930. Owned by the Devon Dock Pier & Steamship Company based in Exmouth Docks, the paddle steamer operated from 1892 to 1934 offering pleasures trips during the summer months. She was wrecked at Sidmouth on 27 August 1934 when a freak wave forced her sideways onto the beach. Inset: Two circus elephants causing a splash in the sea at Budleigh, *c.* 1910. Below: Budleigh beach looking towards the mouth of the River Otter on a summer day in 2011. (*Sat-nav: EX9 6NG – Tourist Information Centre*)

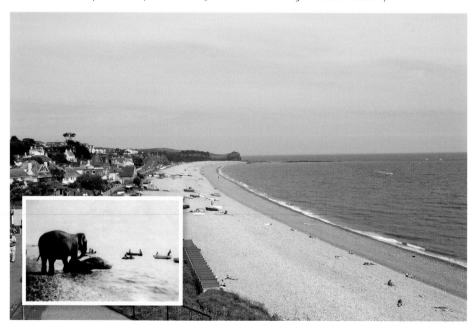

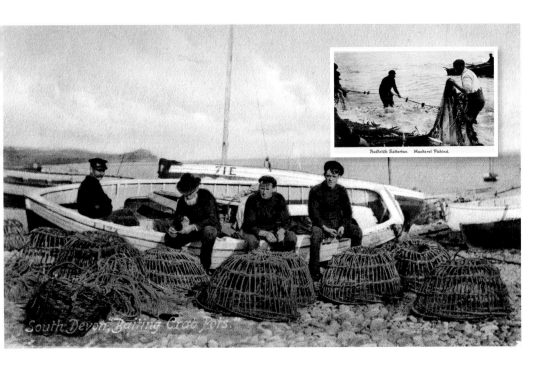

Fishing

Local fishermen, from left to right: Banoss Mears, George Pearcey, Harry Rogers and Will Rogers are pictured baiting their crab pots, *c.* 1930. Inset: Mackerel fishing on Budleigh Beach, *c.* 1900. Below: The only local fisherman working from Budleigh beach in 2011; David Perking (*left of photograph*) pictured with his brother Alan, holding a 7-lb cod caught that morning. David sells his catch from the beach and provides for local restaurants and shops. (*Sat-nav: EX9 6NG – Tourist Information Centre*)

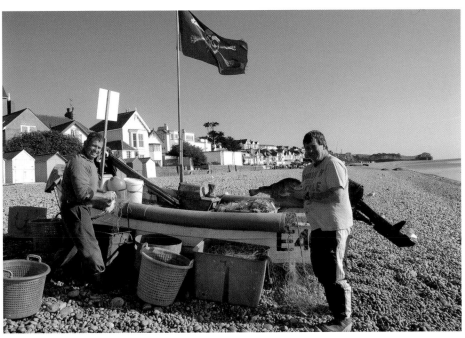

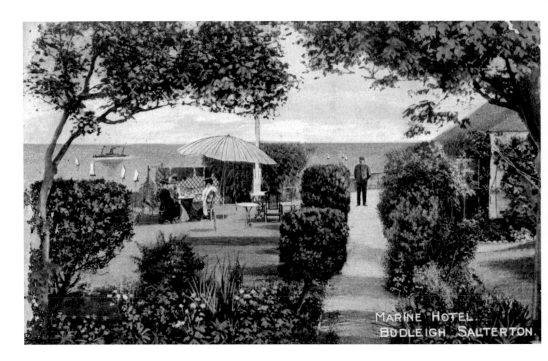

Marine Hotel

This postcard, dated 1909, shows the scenic view of the Marine Hotel gardens, Budleigh Salterton, looking out over Lyme Bay. Below: Annotated 'No. 1', this aerial view shows the site today. Following the demolition of the former building in the 1920s. The site is now occupied by Pebbles Bed & Breakfast. In 2010 it was rated by the *Telegraph* as one of the top ten bed & breakfasts in Britain and Ireland. Pebbles was once the residence of the Duchess of Westminster. (*Sat-nav: EX9 6NG – Pebbles B&B*)

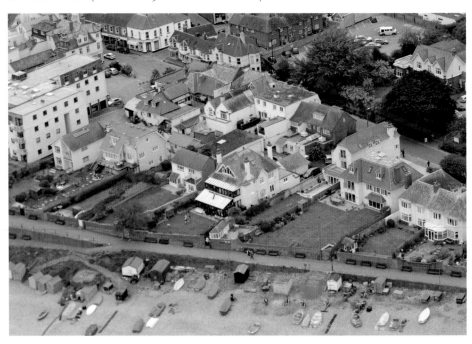

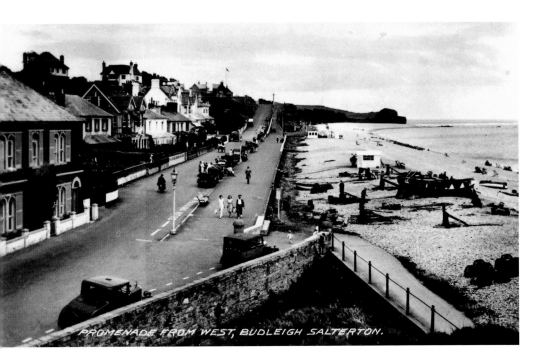

Budleigh Beach

Budleigh beach looking towards Otter Head, *c.* 1930. The building with the flag flying is the coastguard cottage. The war memorial can be seen to the right. Inset: A tableau by the Withycombe Raleigh Women's Institute depicting the famous painting *The Boyhood of Raleigh* by artist Sir John Everett Millais. Below: Budleigh beach in 2011. A blue plaque placed by the Otter Vale Association on the wall behind the flowerpot identifies this as the site of the painting. (*Sat-nav: EX9 6NP – High Street*)

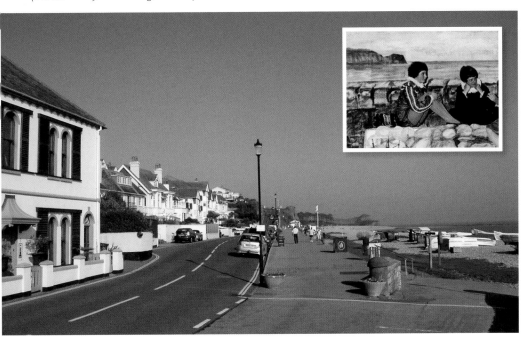

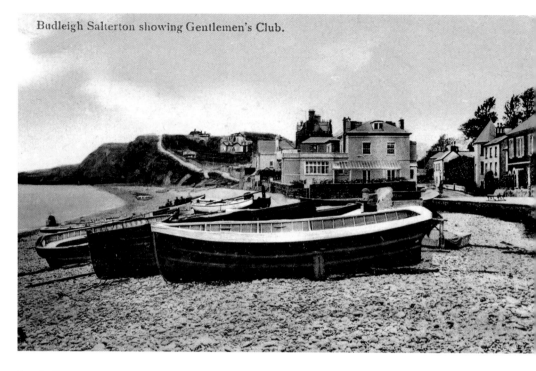

Budleigh Salterton showing Gentlemen's Club.

Sandy Bay

Looking towards Sandy Bay from Budleigh Beach *c.* 1910, this black-and-white photograph has been hand-coloured. The Gentlemen's Club in the centre of the photograph is painted pink. Below: Little has changed in this photograph, taken in 2011. Boats on the beach still remain a feature of this once thriving fishing town, adding to the charm of this tranquil scene. (*Sat-nav: EX9 6NP – Fairlynch Museum*)

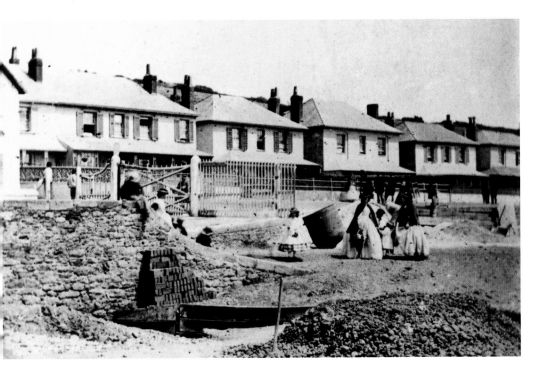

Marine Parade

The Marine Parade, *c.* 1860, shows drainage works on the beach. Note the elegant Victorian fashions, the position of the uniform row of houses and the sloping sea wall. Below: Photographed in February 2012, the same view is hardly recognisable. The houses are now further back, allowing space for the modern road. The sloping sea wall remains mostly unchanged, but has now been extended. (*Sat-nav: EX9 6NP – Fairlynch Museum*)

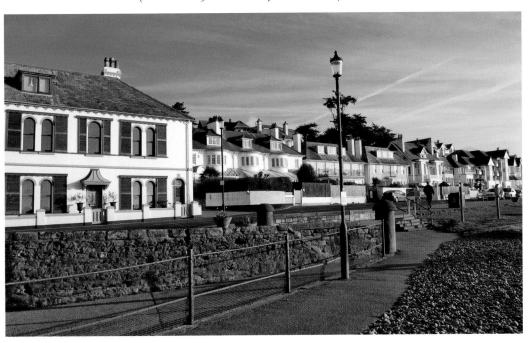

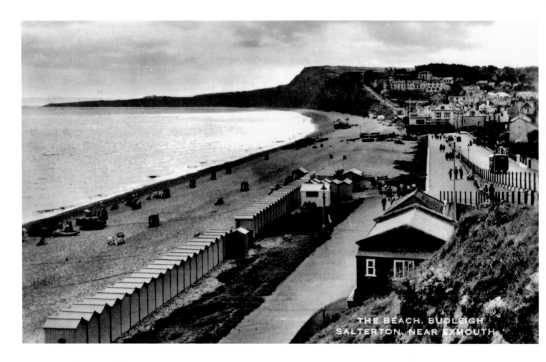

THE BEACH, BUDLEIGH SALTERTON, NEAR EXMOUTH.

Marine Parade

This view, *c.* 1930, looks along Marine Parade towards the town. The stacks of deckchairs on the beach indicate the popularity of this resort. The building in the foreground was built in 1874 to house the coastguard's longboat, which would have been manned by eight to ten oarsmen. Below: This image, taken in the spring 2012, shows the beach huts have not yet been returned for the summer season. Despite pressure to redevelop and modernise, the unique longboat house still remains and is now a café. (*Sat-nav: EX9 6NS – the Long Boat House*)

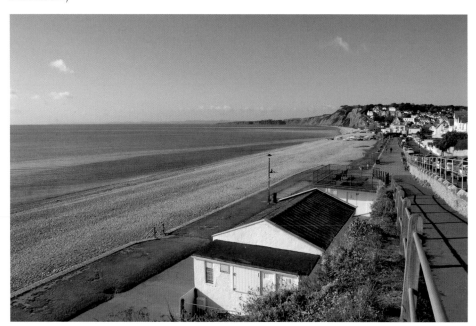

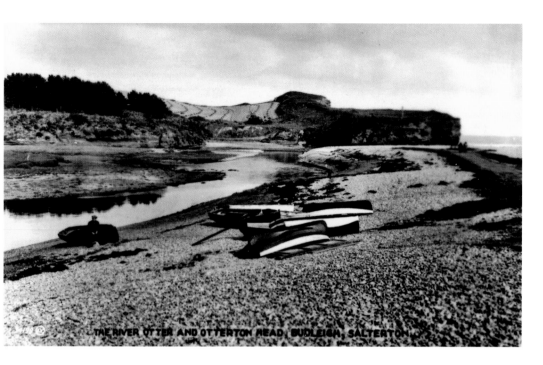

The Mouth of the River Otter, Budleigh Beach

A series of storms during the reign of Henry VIII formed a pebble ridge, which led to the silting up of the salt marshes, preventing the passage of trading vessels, and thus the eventual decline of East Budleigh port. It is seen above around 1930. Below: This panoramic view shows the wider area in 2011, part of which is now Lime Kiln car park. (*Sat-nav: EX9 6NS – the Long Boat House*)

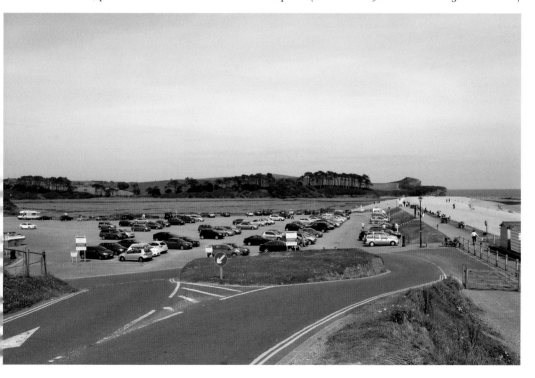

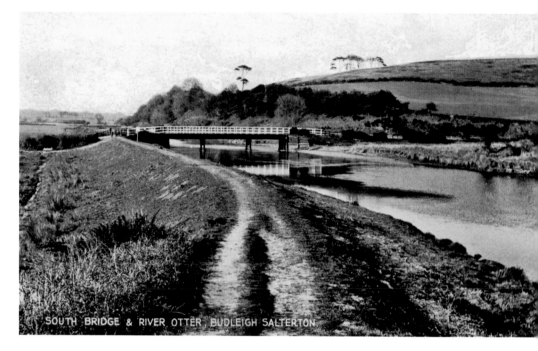

SOUTH BRIDGE & RIVER OTTER, BUDLEIGH SALTERTON

South Bridge

Taken from a postcard dated 1928, this picture shows South Bridge over the River Otter. It is situated approximately a mile from the mouth of the river. Below: This view in 2010 shows the 1960s concrete replacement bridge. The area has been a nature reserve since 1982 and allows for important recreational activities such as walking and birdwatching. (*Sat-nav: EX9 7AY – South Bridge Farm*)

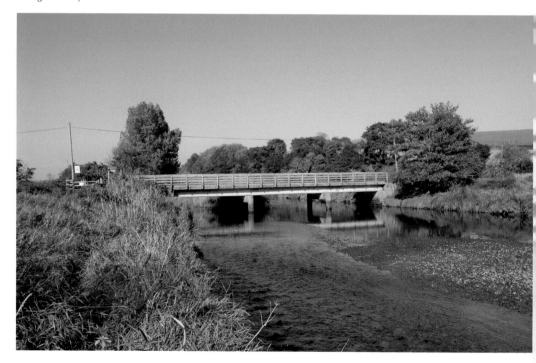

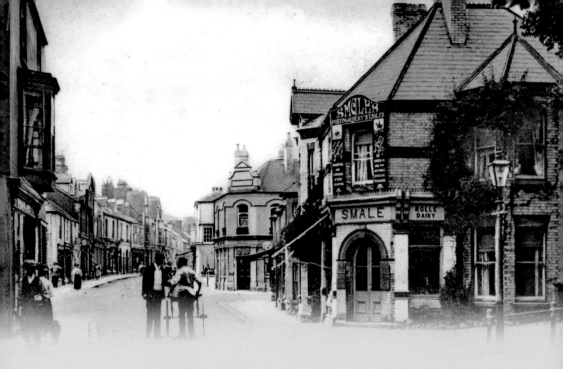

CHAPTER 7

Budleigh Salterton Town
& Surrounding Area

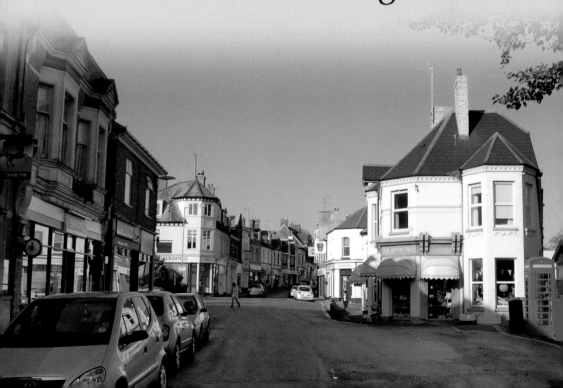

BUDLEIGH SALTERTON, MILLAIS'S HOUSE.

The Octagon

This postcard, *c.* 1958, shows the Octagon on Fore Street, where Sir John Everett Millais stayed in 1870 while painting his famous picture *The Boyhood of Raleigh*. The painting depicts a young Sir Walter Raleigh being inspired to travel to far-off places. In the early 1900s, the Budleigh Brook flowed in front of the houses on the right-hand side of the road where there is now a pathway. Below: The same scene in 2011. The garden to the left of the photograph belongs to the Fairlynch Museum, which features many special exhibitions each year. (*Sat-nav: EX9 6NP – Fairlynch Museum*)

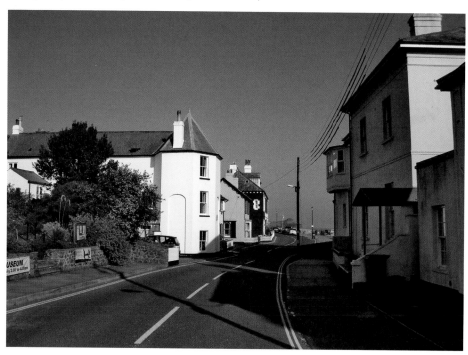

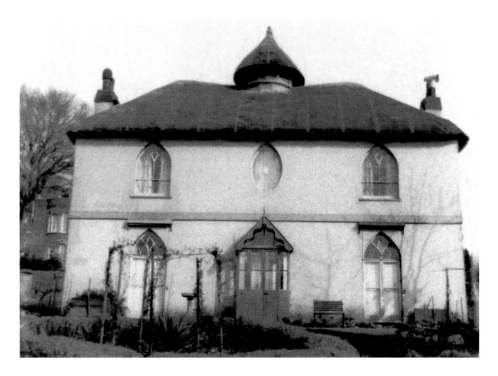

Fairlynch

Fairlynch, pictured here *c.* 1930, was built as a private residence *c.* 1811 by shipowner Matthew Le Yeates. The turret on top of the thatched roof was added to give a good view of his ships arriving loaded with limestone, coal and timber. Below: Fairlynch Museum was opened in July 1967 by Miss Joy Gawne, her sisters, and Mrs Priscilla Hull as a 'Project of Victoriana'. Donated to the Charitable Trust, it is now solely run by volunteers, having strong links with local schools and colleges. The museum is open to the general public from Easter until the end of September. (*Sat-nav: EX9 6NP – Fairlynch Museum*)

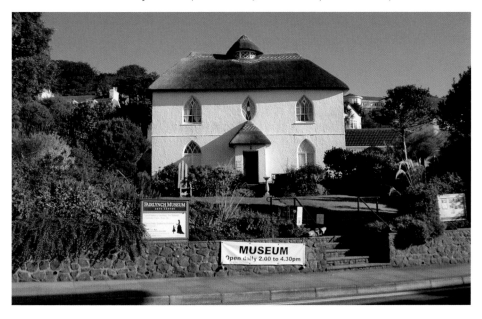

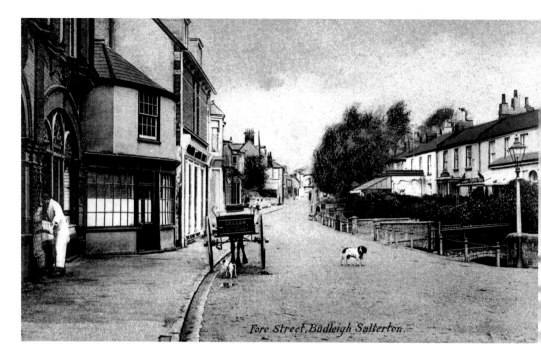

Fore Street, Budleigh Salterton.

Fore Street

This handpainted, black-and-white photograph brings a touch of colour to this Edwardian scene of Fore Street, *c.* 1905. Note the absence of motor vehicles in an age where goods were delivered by horse and cart. Inset: A photograph taken *c.* 1880, showing the laying of the waste water pipes alongside the brook. Below: Budleigh Salterton today. The character of the town is retained in the many specialist shops and quaint boutiques, giving a unique shopping experience, particularly during the popular annual Christmas shopping evening. (*Sat-nav: EX9 6NH – Fore Street*)

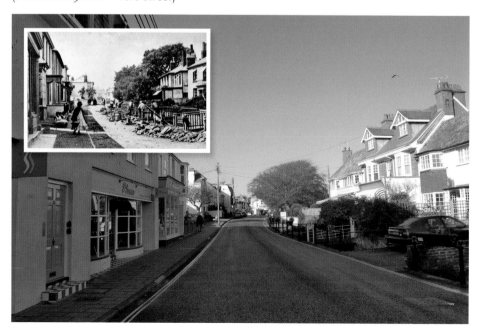

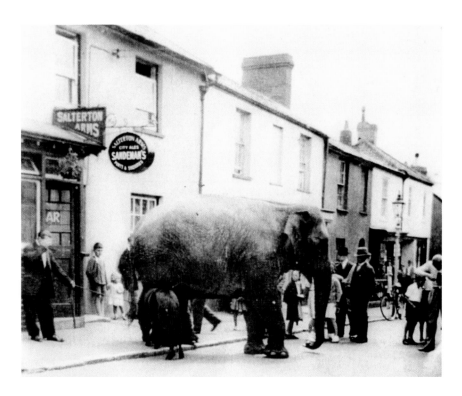

The Salterton Arms

This photograph, *c.* 1910, captures an interested crowd gathering outside the Salterton Arms in Chapel Street to see the pony and elephant, advertising the arrival of Lord Sander's Circus. Below: This beautiful floral display outside the Salterton Arms in 2011 contributed to the town's Britain in Bloom competition. This family and dog friendly pub has a restaurant upstairs offering an extensive menu. (*Sat-nav: EX9LX – Salterton Arms*)

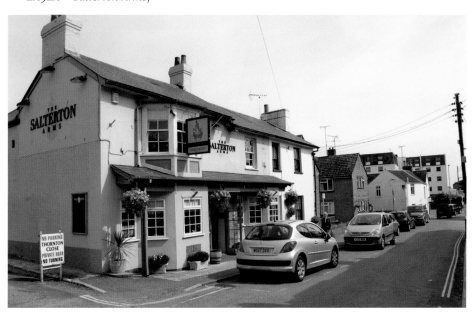

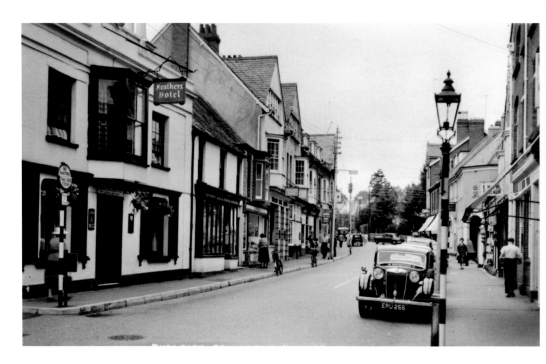

High Street

This photograph shows the charm of the High Street in 1958. The Feathers Inn, dating back to the sixteenth century, and the post office to the right of the lamp post, remain a feature of the street today. Below: The same view in 2010, with a banner advertising the Literary Festival in its second year; one of the many annual events of the town. There is also a Jazz Festival in April and the Music & Arts Festival in July. (*Sat-nav: EX9 6NB – Postal Sorting Office*)

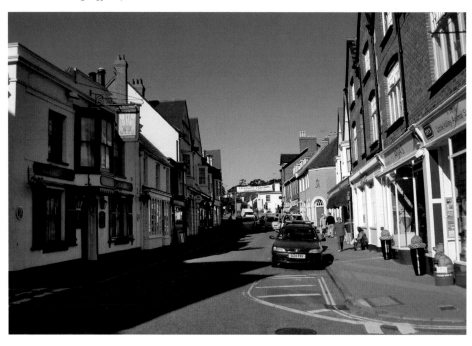

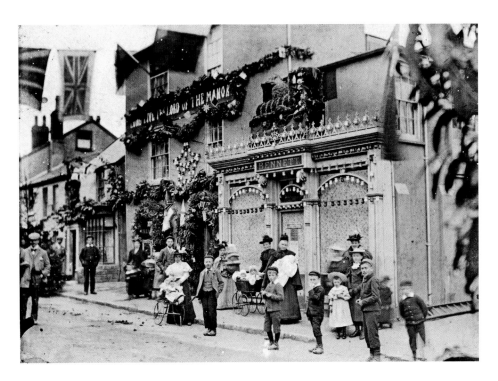

High Street

Bennett's Ironmongers is decorated with a floral steam locomotive to celebrate the opening of the Budleigh Salterton branch line to Tipton St John on 14 may 1907. The banner 'Long Live the Lord of the Manor' honours Lord Rolle, who allowed the railway line to cross his estate. The bunting and flags denote that the town was also celebrating Queen Victoria's Diamond Jubilee. Below: The site is now occupied by Staddons Garage. (*Sat-nav: EX9 6LQ – Staddons Garage*)

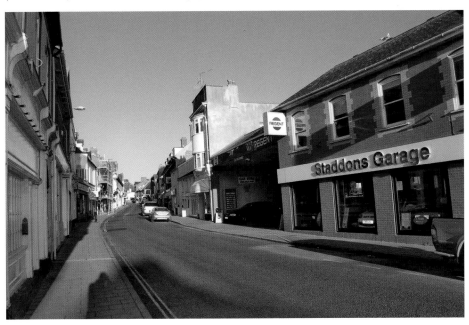

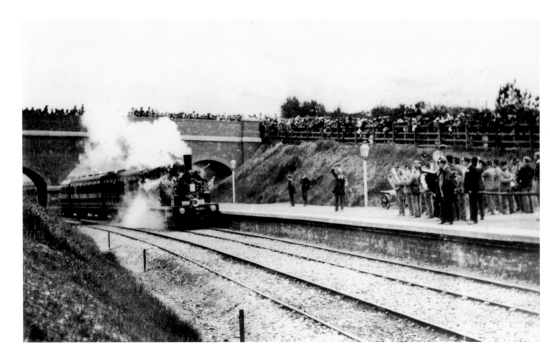

Budleigh Salterton Station

On 14 May 1897 a large, excited crowd gathered to witness the arrival of the railway company dignitaries and guests aboard the first train to pull into Budleigh Salterton Station. It opened to the general public the following day and connected Budleigh Salterton to the mainline via Sidmouth Junction (Feniton) and Tipton St John. The link from Budleigh Salterton to Exmouth did not open until 1903. Below: Photographed from the railway cutting on the other side of the bridge in 2012; the Stanley Mews flats can be seen behind. (*Sat-nav: EX9 6JR – Stanley Mews*)

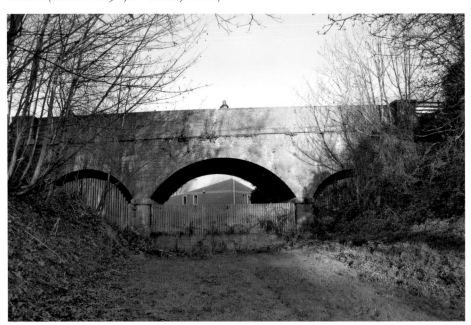

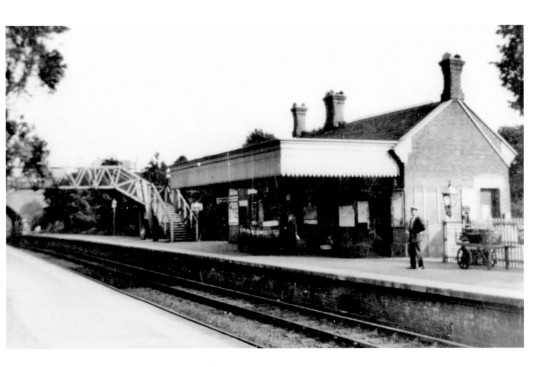

Budleigh Salterton Railway Station

Following the Beeching Report, the Budleigh link line was closed on 4 March 1967. The capped gentleman in the picture, *c.* 1930, is thought to be the Harts bus driver awaiting passengers from the 18.28 Exeter train for their onward journey to surrounding villages. Below: Stanley Mews, named after stationmaster Stanley Murch, stands on part of the station site. For a time Norman's Cash & Carry also occupied part of this site, but has since been demolished and further housing built. (*Sat-nav: EX9 6JR – Stanley Mews*)

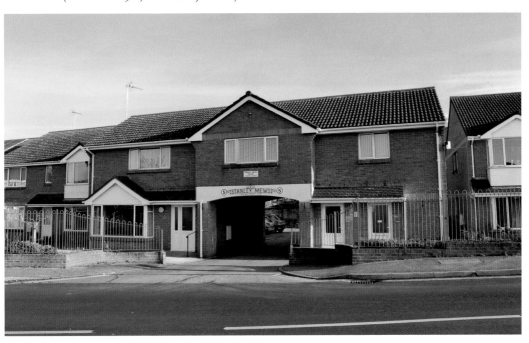

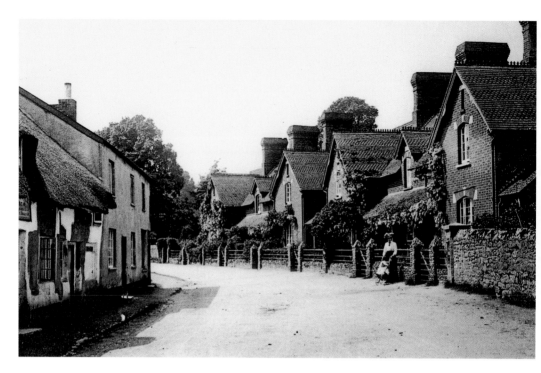

Knowle Village

Rolle Cottages, to the right, were among the many in East Devon funded by Lord Rolle. The thatched cottage to the left is the original Britannia Inn *c.* 1890, before it was demolished and rebuilt. Below: the Britannia Inn, summer 2011, also known as the Dog & Donkey, after the landlady, who used a donkey and cart to deliver coal around the area. The beautiful floral display is the handiwork of Colin Lock, who can be seen to the left of the photograph. (*Sat-nav: EX9 6AL – Dog and Donkey*)

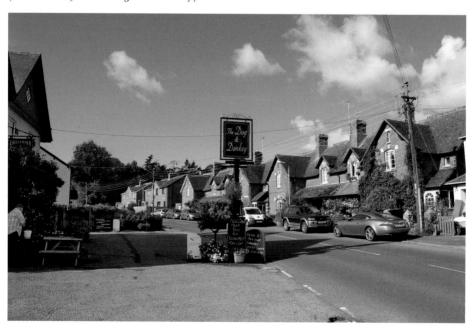

CHAPTER 8

East Budleigh Area

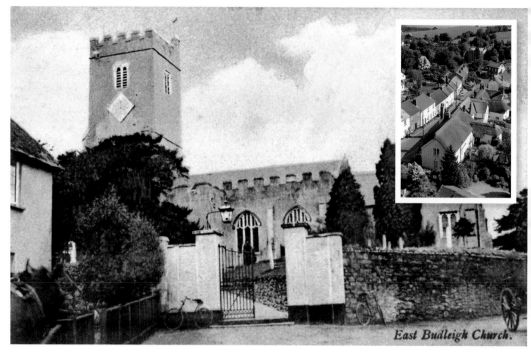

East Budleigh Church.

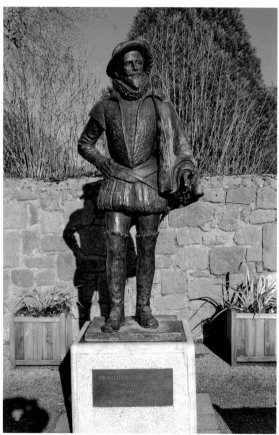

East Budleigh, All Saints Church
The history of the church is thought to date back to Saxon times. It played an important role in Sir Walter Raleigh's early education when Revd Ford tutored him in the mid-1500s. It is pictured above *c.* 1905. Inset: Captured in 2010 by photographer Michael Tuska, this image shows East Budleigh High Street from the church tower. A hexagonal toll-house once stood at the bottom of the street and each year, during the annual scarecrow competition, a toll is reinstated to enter the village. Left: Sir Walter Raleigh's statue at the top of the High Street. (*Sat-nav: EX9 7DB – All Saints Church*)

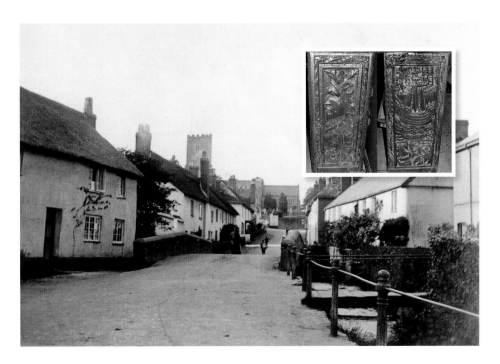

Looking Up East Budleigh High Street

This image shows a typical picturesque Devon village with thatched cottages and the church in the background, *c.* 1913. Inside the church there are a number of unique oak bench-ends, carved over 400 years ago, with designs depicting the influences of life in this once-bustling port town. Inset: Bench-end examples include a Native American and an early sixteenth-century sailing ship. Below: in 2011 little has changed, and pride in the village is evident by the well-tended floral displays and buildings. (*Sat-nav: EX97ED – Sir Walter Raleigh Public House*)

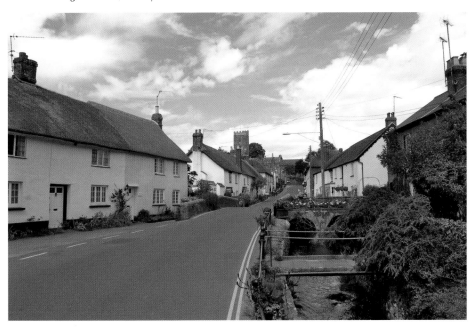

Kings Arms, East Budleigh

This picture, *c.* 1950, shows the King Arms, East Budleigh, formerly known as King William IV and now known as Sir Walter Raleigh. The public house was formed in the eighteenth century, at first occupying just one of two sixteenth-century cottages. The two cottages merged in the late 1970s to provide the present-day pub layout, forcing the closure of the Jug & Bottle off-licence. Below: Specialising in homecooked food and CAMRA-recommended real ales, the Sir Walter Raleigh pub during a visit from the Raddonhill Clog Morris Dancers in 2010 (picture by Michael Tuska). (*Sat-nav: EX9 7ED – Sir Walter Raleigh Public House*)

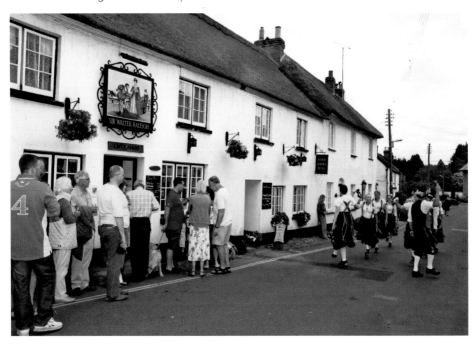

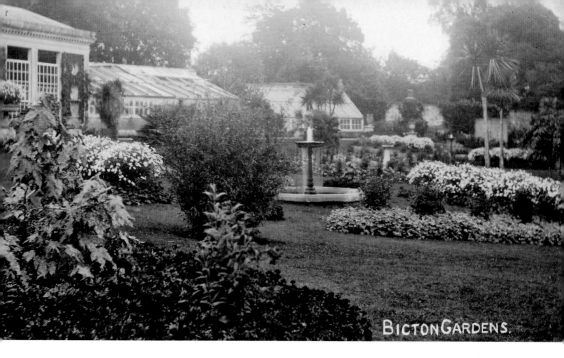

Bicton Gardens

Bicton Gardens, pictured here *c.* 1910, have been popular for many years. Among the more prominent visitors to have enjoyed the tranquillity of the gardens were Winston Churchill, and King George VI and Queen Elizabeth when they were courting. After a period of neglect, in 1961 the gardens were restored and they opened to the public in 1963. Below: Today Bicton Park offers 63 acres of gardens and parkland, including the formal Italian Garden pictured here, with the Palm House to the left. (*Sat-nav: EX9 7BG – Bicton Park*)

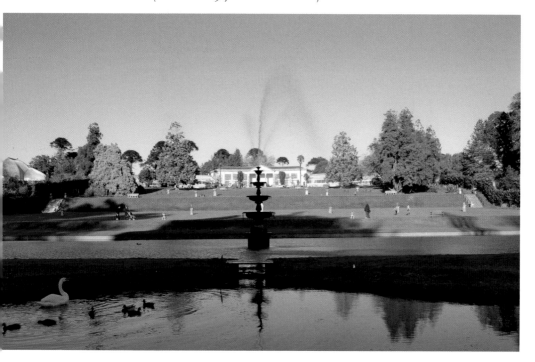

Otterton Mill

This picture, *c.* 1900, shows Green Cottages and The Green, Otterton. Otterton Mill, seen in the background to the left, was run from 1905 by Withycombe millers Henry and Harry Long until its closure in 1962. Below: The same scene in 2011. Otterton Mill is now a tourist attraction and has re-established itself as a flour mill, producing wholegrain flour, with an artisan bakery, restaurant, craft and gift shop. (*Sat-nav: EX9 7HG – Otterton Mill*)

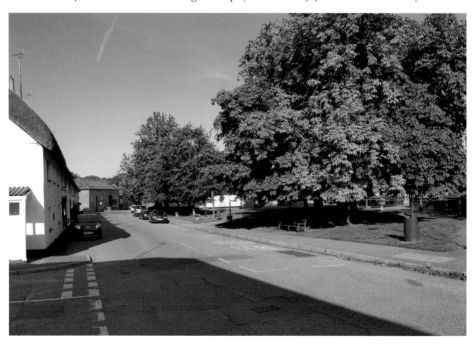

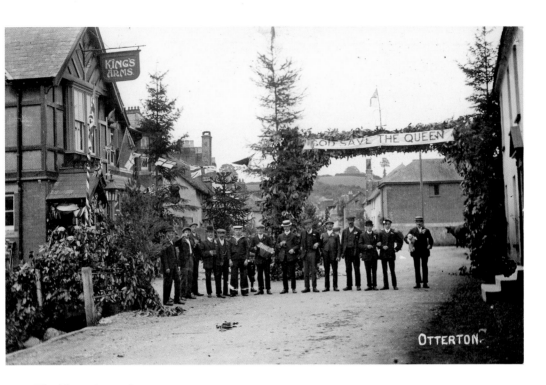

The Kings Arms, Otterton

Following a rebuild in 1889, the Kings Arms, Otterton, is pictured during Queen Victoria's Diamond Jubilee celebrations in 1897. In the 1930s dances were held on Sundays after church in the hall above the bar. Below: Pictured outside the Kings Arms on 4 June 2012, during Queen Elizabeth II's Diamond Jubilee celebration, are, from left to right, Clive Parnell, Bruce Simpson, Jimmy Fee and Christopher Long. (*Sat-nav: EX9 7HB – The Kings Arms*)

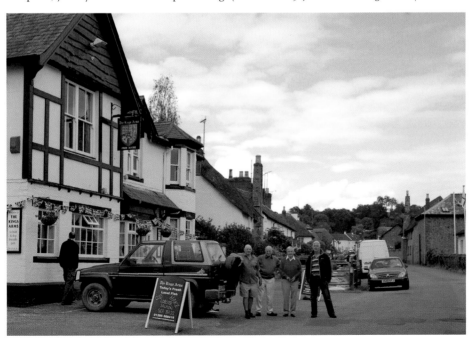

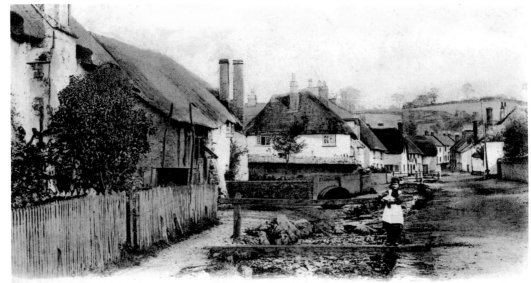

Otterton Village

Otterton Village

This cropped postcard showing Otterton Village can be dated pre-1904 as it had a space on the front allowing room for a message; the back of postcards were used only for the address. Brothers Harry and Frank Smith sold the produce of their market garden from the back door of the cottage pictured on the left. At that time there was a butcher, baker, newsagent, public house and post office/general store in the village. Below: Today, with the exception of the Kings Arms, none of these facilities remain. (*Sat-nav: EX9 7HB – Otterton Village*)

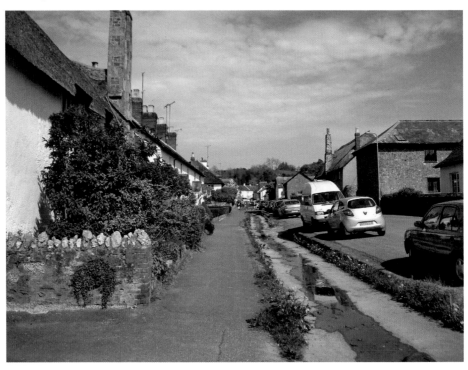

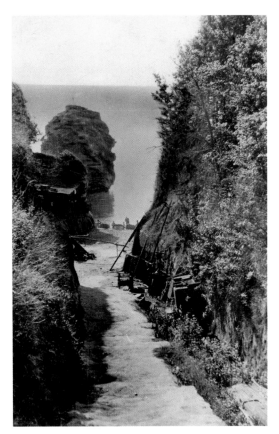

Ladram Bay

Around the turn of the nineteenth century, Ladram Bay was known for smuggling activities. One of the more famous local smugglers, Jack Rattenbury, known as the 'Rob Roy of the West', had his *Memoirs of a Smuggler* published in 1837. Below: The same view in 2011 shows the coastguard's cottage built in 1834 to combat smuggling. Ladram Bay has been a family-run holiday park since 1943. (*Sat-nav: EX9 7BX – Ladram Bay*)

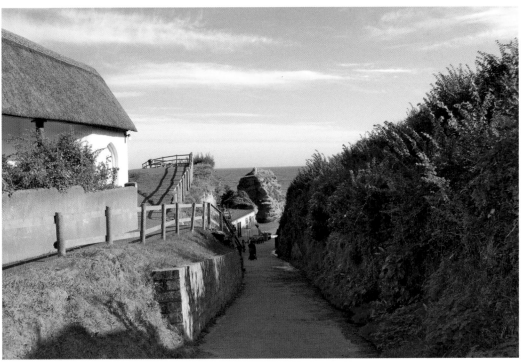

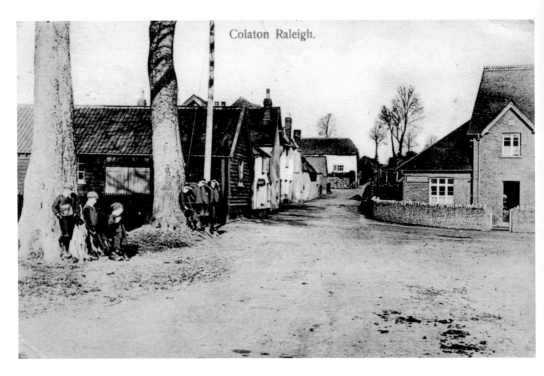

Colaton Raleigh.

Colaton Raleigh, *c.* 1907
The building to the right of the photograph was a post office and general store, and the wooden building to the left was a carpenter's/smithy. Below: The same area in 2011. The post office and stores have now closed, although a village shop remains and can be seen to the left of the photograph. (*Sat-nav: EX10 0HJ – Colaton Raleigh Village*)

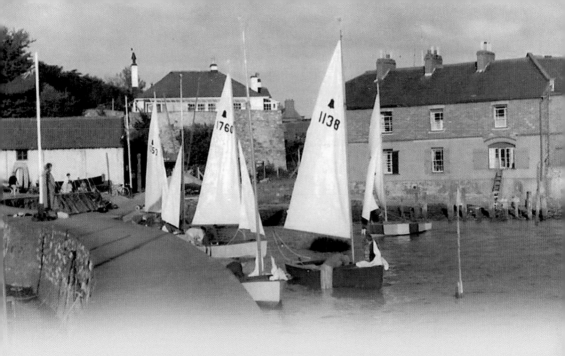

CHAPTER 9

People of East Devon

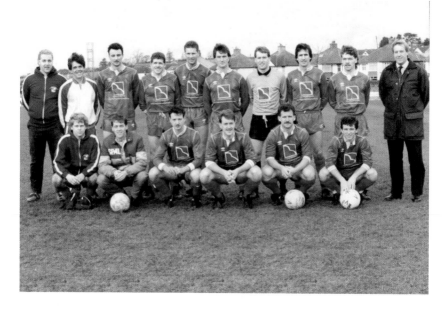

Exmouth Town Amateur Football Club (AFC)

Pictured above in 1988/89 are, from left to right, back row: Mike Skinner, Jerry Sharland, Lenny Jones, Steve Hynds, Andy Rowland, Mark Gennard, Mike Barrett, Robbie Hook, Kevin Smith, Bob Davis. Front row: Frank Howarth, Paul Dixon, Keith Sprague, Jon Beer, Alan Hooker, Gary Carpenter. Below: Exmouth Town AFC 2011/12. From left to right, back row: Rob Hayes, Sam Schaefli, Alex Hughes, Chris Wright, Jody Bolt (Manager), Ali Sawer, Mark Simic, Adam Turner, Josh Kirby. Front row: Andrew Jones, Jac Civill, James Turner (Captain), Jamie Moore, Sam Woodin, Dan Plater, Tom Lowe, Kerry Butler. (*Sat-nav: EX8 3EE – Exmouth Town AFC*)

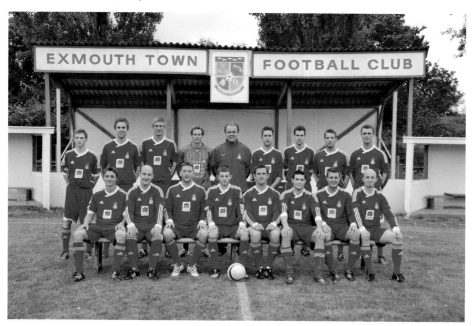

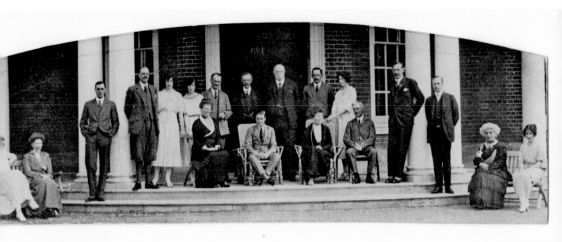

Bicton House, *c.* 1920

Edward, Prince of Wales, seated centre with the 21st Lord Clinton, stood behind to the left, was among many distinguished guests to visit the estate. Seated to the far right of the photograph is Elizabeth Bowes-Lyon, later to become Queen Elizabeth, the Queen Mother, who was related to the Clinton family through marriage. Below: During a reunion in May 2012, twenty-five former pupils of St Ronan's Preparatory Boys' School are pictured with the 22nd Lord Clinton (front row, third from right). They visited Bicton House, where their school had been relocated from West Worthing during the war from 1940–45. Bicton College has occupied the house and grounds since 1947. (*Sat-nav: EX9 7BY – Bicton College*)

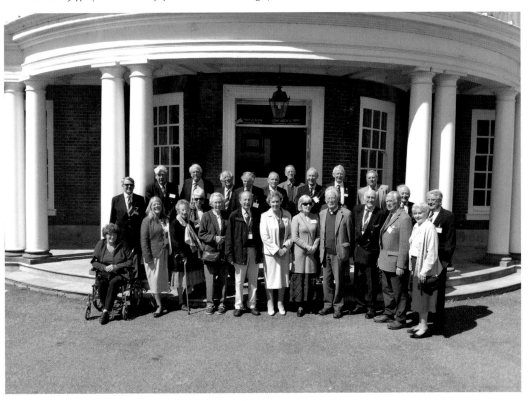

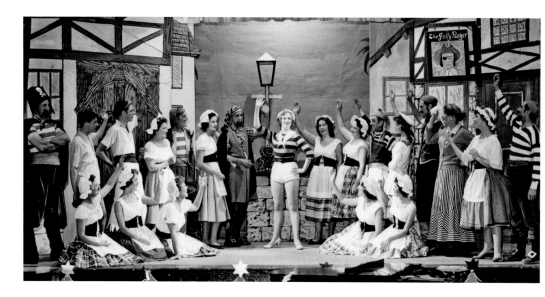

The Exmouth Players

The Exmouth Players during their pantomime, *Robinson Crusoe*, in 1960. Formed in 1910, formerly the Exmouth Amateur Dramatic Club, the Exmouth Players acquired the Blackmore Theatre, on Bicton Street, in 1979. Below: The Players in October 2009 during their production of *Daisy Pulls It Off* by Denise Deegan. From left to right, back row: Lee Haddow, Barbara Searle, Jenny Bowden, Mike Brookes, Karen Brookes-Ferrars, John Hatchard; Middle Row India Laurence, Hellen Ballard, Barbara Pentecost, Daphne Fensom, Ruth Tompkins. Front row: Jane Spamer, Wendy Bishop, Alice Brookes, Sheila Urwick, Christine Hatchard, Annabel Bunyard. The Players have a pantomime in January, four other major productions and a One-Act Festival in April. (*Sat-nav: EX8 2RU – The Blackmore Theatre*)

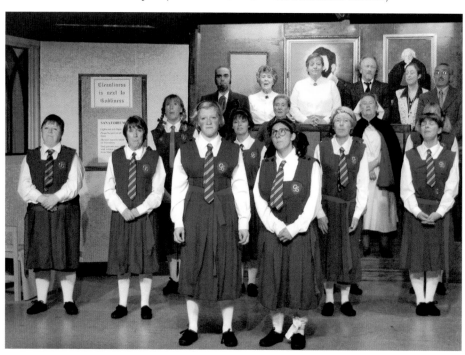

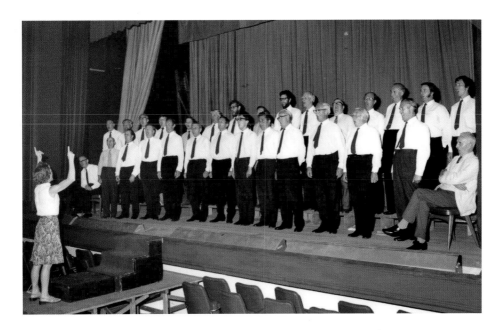

Budleigh Salterton Male Voice Choir

Budleigh Salterton Male Voice Choir's first concert at the Exmouth Pavilion, 13 July 1975, conducted by Pam Jones. Below: On 17 March 2012, following a fundraising event for the Sidmouth Rotary Club at All Saints church, Sidmouth. The choir currently has sixty-five members, whose dedication has helped to raise an average of £10,000 a year for local charities through their monthly concerts. Equally committed to the choir are those seated (left to right): President Pam Jones, Musical Director Peter Good, Accompanist Sandra Jepps and her assistant Jenny Newman. The choir meets every Tuesday evening at St Peter's church hall. (*Sat-nav: EX9 6LT – St Peter's church*)

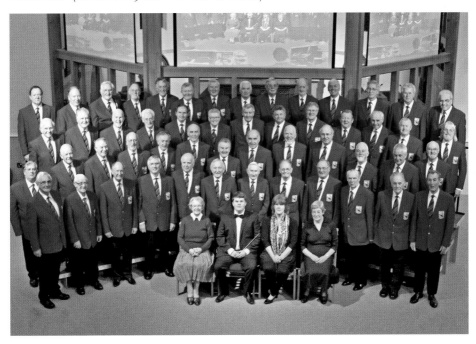

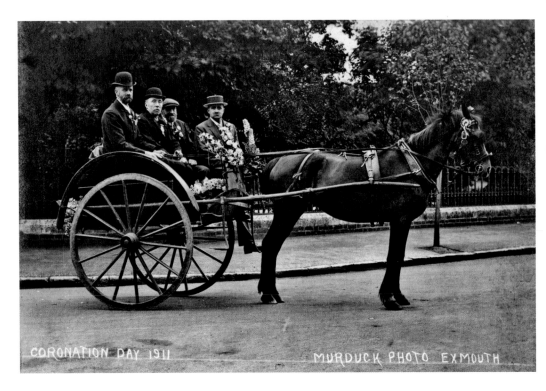

Royal Occasions

Exmouth Urban District Council/Coronation Committee as they arrive in the Strand, Exmouth, to celebrate the coronation of King George V in June 1911. Below: Pictured on 4 June 2012, Renaissance Ladies' Barbershop Chorus in the Strand prior to starting Exmouth's Diamond Jubilee celebrations for Queen Elizabeth II. Pictured with them are Exmouth's Mayor, John Humphreys (front row, left), and Town Crier Roger Bourgein (front row, centre). Renaissance were formed in July 2005 by Musical Director Maire Hoppins (left of Roger) seen here with the chorus members. Today they have over forty members and perform regularly at local venues and festivals, winning two awards at the Exeter Music Festival in 2012. (*Sat-nav: EX98 1BR – The Strand*)

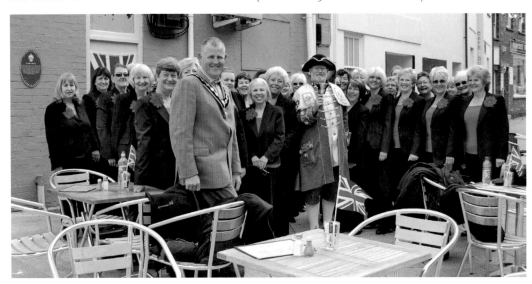

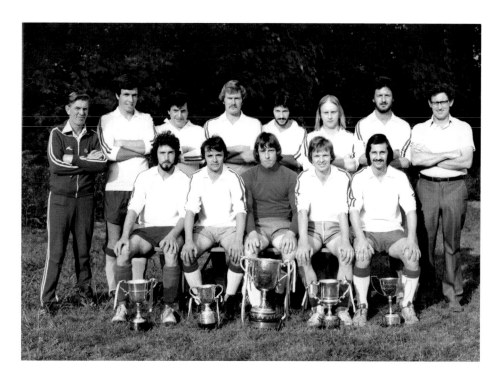

East Budleigh AFC First Team

East Budleigh AFC first team 1977/78 following a successful season. Left to right, back row: R. Murdock, R. Butcher, D. Webb, S. Richardson, J. West, R. Barnard. Front row: S. Grainer, D. Pratt, S. Pratt, M. Smith, C. Pratt. Below: End of season presentation day and friendly match, Married v Singles, 19 May 2012. Left to right, back row: Alex Manning, Steve Davewy, Adam Jones, Alex Wheatley, Phil Page, Chris Eveleigh, Mark Brown, Dave Mills, Si Tuley, Dan Reynolds, Paul Carnell, Lee Irvine, M. R. K. Wagstaffe, Zack Pearce, Kevin Hawthorne. Front row: Rich Wyatt, Jimmy Wangdi, Dave Evans, Jack Howarth, Tom, Colin Jeans, Andy Case, Craig Leaman, Spencer West, Martin Marriott, Tim Whiteoak, Matt Jones. (*Sat-nav: EX97BY – East Budleigh AFC*)

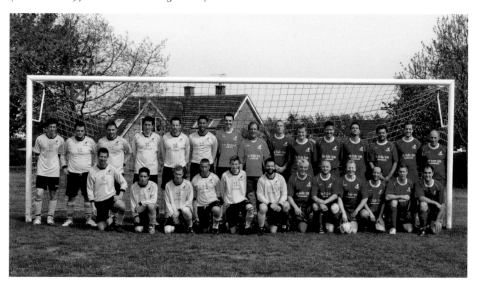

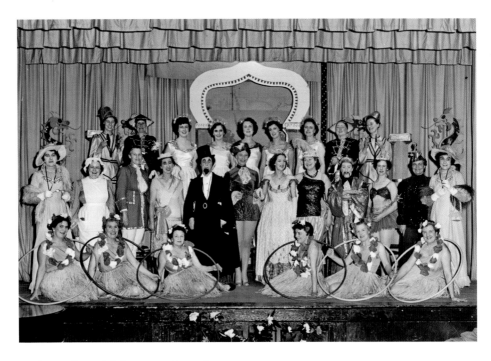

Withycombe Raleigh Women's Institute

Withycombe Raleigh Women's Institute, January 1959, during one of their annual pantomimes, *A Lad In Withycombe* by Doris Heard. Doris was the driving force behind the drama section at that time and their shows were always a sell-out. Formed in 1937, with seventy members, the group increased to 250 members at its peak post-Second World War. During the war they formed sewing circles to mend and make children's clothes for the evacuees billeted to the area. Below: Members are pictured outside Withycombe church during 2010, where they meet monthly. Still popular, with 100 members, they celebrated their seventy-fifth anniversary in 2012. (*Sat-nav: EX8 3AE – Withycombe Church Hall*)

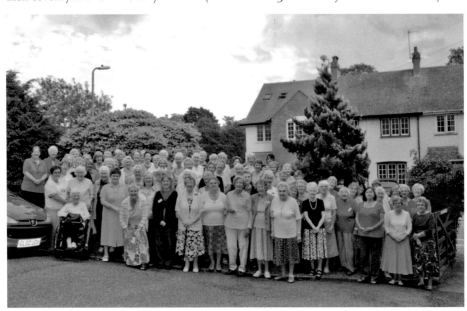

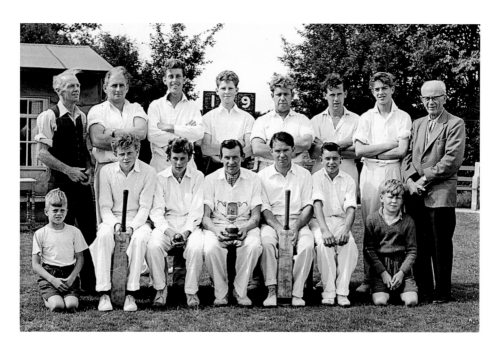

Woodbury Cricket Team

Pictured above, *c.* 1958, are, from left to right, back row: Alfie Hares, Peter Southall, Mr Day, Clive Radford, Robert Stevens, Roy Marks, Ken Sellick and Mr Scott. Front row: Peter Southwell (?), Victor Fox, Bob Miller Jnr, Bob Miller Snr, Stan Gooding, Peter Sellick and Mervyn Radford. Below: Woodbury Cricket Team, 2012. Left to right, back row: Chalky White (Umpire), Toby Ingham, James Taylor, James Kavanagh, Jimmy Jones, Nalin Chouham, Adam Olesky, Cyril Bamsey (Scorer). Front row: Richard Arnold, James Watson, Kevin Miller (Captain), Liam Cook and Martin Cook. The team have occupied the ground in Town Lane since 1992. The pavilion was built mainly by club members with help from local tradesmen. (*Sat-nav: EX5 1NF – Woodbury Cricket Club*)

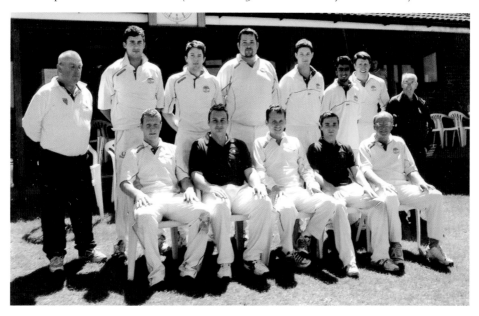

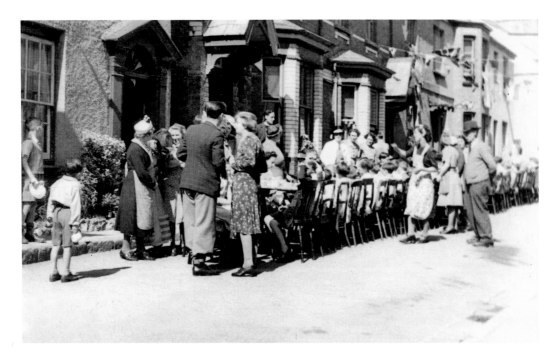

Bicton Street

Bicton Street residents during their celebrations for King George VI's coronation, 12 May 1937. Earlier that day, Local Exmouth groups, schools and organisations processed to a service of thanksgiving held in the Manor Gardens, which ended in time to allow the congregation to listen to the live radio broadcast from Westminster Abbey. Below: Celebrating Queen Elizabeth II's Diamond Jubilee on 4 June 2012, Bicton Street had a day packed with festivities including live music by the Exmouth Shanty Men, a coronation chicken lunch and barn dance followed by a high tea. (*Sat-nav: EX8 2RU – The Bicton Arms*)

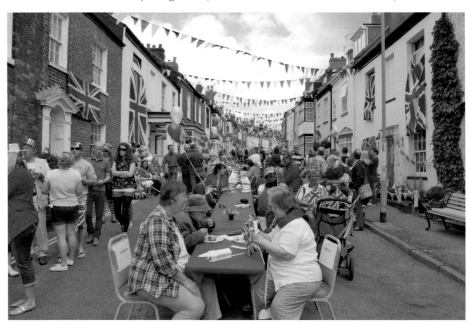